Paris

PHOTOGRAPHED BY RIVER THOMPSON

It's early morning in Paris and the traffic circling the Arc de Triomphe is starting to slow. Golden light – the same light that inspired such artists as Pierre-Auguste Renoir and Claude Monet – illuminates the carved inside of the arch. You'll find several photos of the Arc de Triomphe (and equally familiar Eiffel Tower) among these pages but this is a book about so much more than a tourism tick-list of the French capital's highlights.

Our goal was to chronicle a day in the life of this great city from the perspective of a photographer who knows and loves it. We wanted to present not just the famous sights but also Paris's daily rhythms as a local would experience them. The book is loosely organised according to the passage of a day and night in the city: we start with savouring a coffee at one of the many corner cafes, take in a fruit-and-vegetable street market, admire the view of Paris's rooftops from the Galeries Lafayette's seventh floor terrace, and then, as true Parisian flâneurs, leisurely explore the city's neighbourhoods and their signature experiences. We discover secret urban farms, streets of bijou boutiques, grand museums, classic and contemporary architecture. We end the day

atop a hillside with a bottle of wine watching the sun set, before hitting one of Paris's jazz clubs. It would be impossible to capture all of Paris's incomparable variety but readers will discover a side to the city beyond the famous sights.

For a task of this scale, we sought a photographer for whom Paris was a source of inspiration. River Thompson – who grew up in France – shoots a variety of editorial stories around the world. 'For this book,' says River, 'I wanted to capture the beautiful everyday moments in Paris: the sharp shadows in the morning, the colours, the sounds of locals, tourists and the quiet cobbled streets.' Helping River was caption-writer Nicola Williams, a long-standing Lonely Planet writer who lives on the southern shore of Lake Geneva but regularly visits Paris, where she has spent years revelling in its extraordinary art, architecture, shopping and cuisine.

Between them, they photographed and described all these aspects of Parisian life. The result is this chronologically-ordered visual odyssey through one of the world's great cities, a taste of Paris that may give first-time visitors fresh ideas of what to see and do, and also inspire long-time lovers of the French capital to make another trip to 'le gai Paris'.

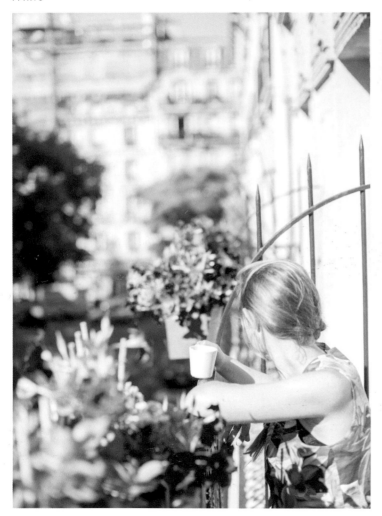
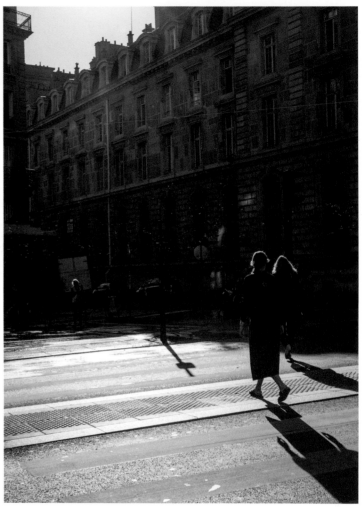

As the day gets underway in the French capital, streets fill with Parisians heading to work on foot or by metro. Weekends begin with a contemplative *café* (espresso), the morning coffee de rigueur for most French, on one of the balconies that became all the rage after Baron Haussmann's redesign of the city from 1853.

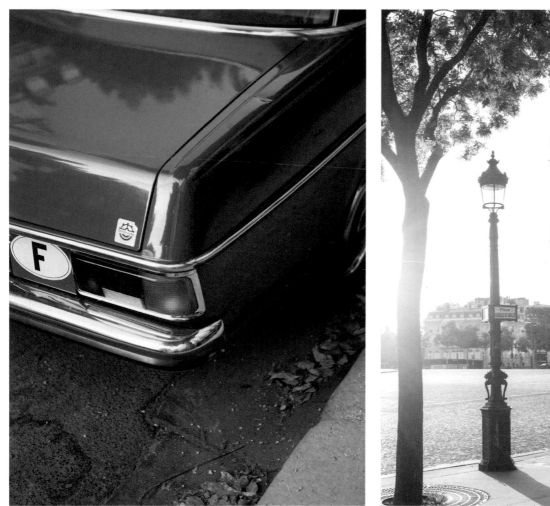

Parisian drivers must contend with not just a paucity of parking spaces but also navigating Place Charles de Gaulle, where 12 traffic-busy avenues meet. It was created in the mid-19th century by city planner Baron Haussmann, who was ordered by Napoleon III to rid medieval Paris of its tangle of stinky, dark, narrow streets.

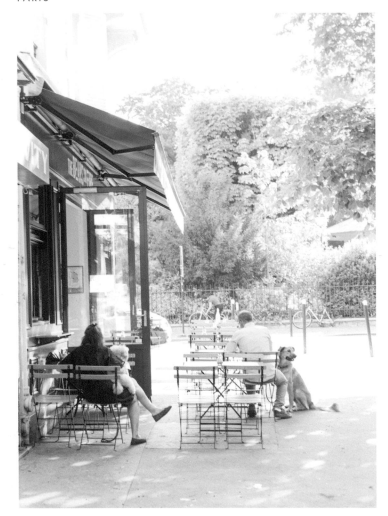

In a city jostling with coffee lovers, third-wave coffee shop and craft-roaster The Beans on Fire in the 11e shines. Colombian duo Andrés and Maria are the creative pair behind the shop – the first to introduce collaborative roasting to the capital's coffee scene.

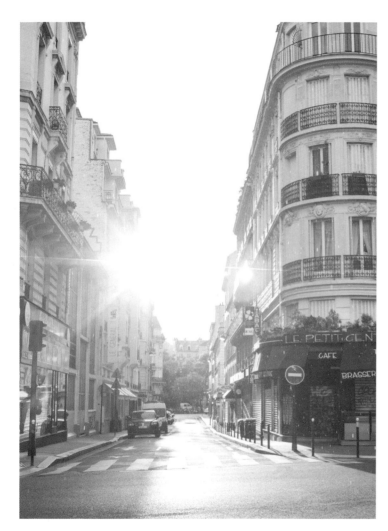

The sun rises on Rue Rampon, an unassuming side-street round the corner from Place de la République in the young, fun, nightlife-hot 11th arrondissement.

The glittering-gold winged Liberty atop the 47m-high Colonne de Juillet marks the spot on Place de la Bastille where the famed 14th-century prison stood.

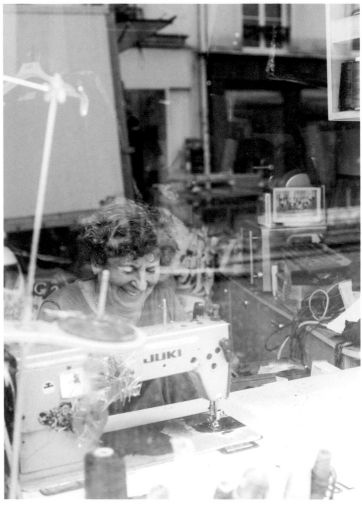

0800: Rue de Turenne cuts through the heart of the fashionable Marais and is a veritable snapshot of life in the 3e, with its cafes, shops, art galleries, peeling billboards and tiny seamstress workshops. The street was named after a 19th-century marshal-general who lived in a *hôtel particulier* (private mansion) here.

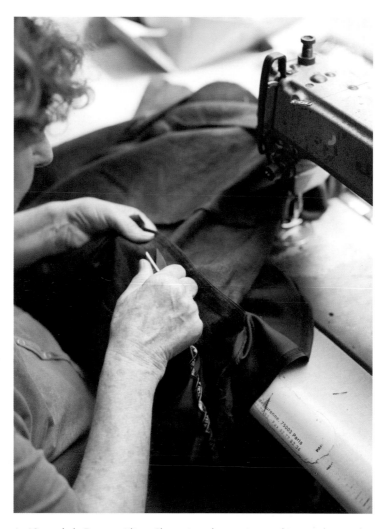

At 69 rue de la Turenne, Liliane Slama sits at her sewing machine, stitching and fixing frocks, socks, *pantalons* and anything else that locals bring in for repair.

Sculpted with mythical creatures and stone nymphs or propped up by golden statues: every one of the Seine's *37 ponts* (bridges) is unique and storied.

Morning joy: Emerging from the packed Metro, used by 1.5 billion passengers a year, onto a sunlit square planted with linden, horse chestnut and plane trees.

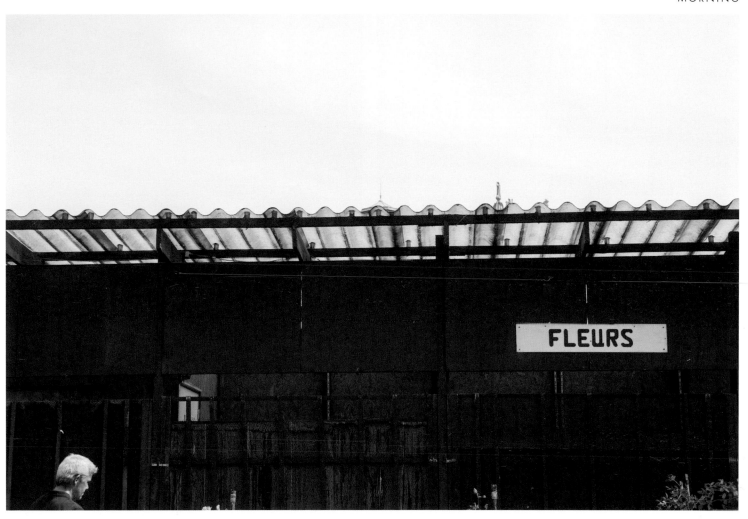

The doors open at Marché aux Fleurs Reine Elizabeth II, the oldest market in Paris, created in 1808 and renamed after the Queen of England during the 70th anniversary commemorations of D-Day in 2014. Squirrelled away in romantic Art Nouveau pavilions on Île de la Cité, the market is *the* place to buy fresh flowers.

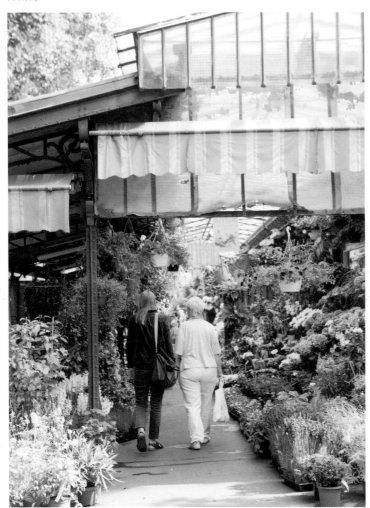

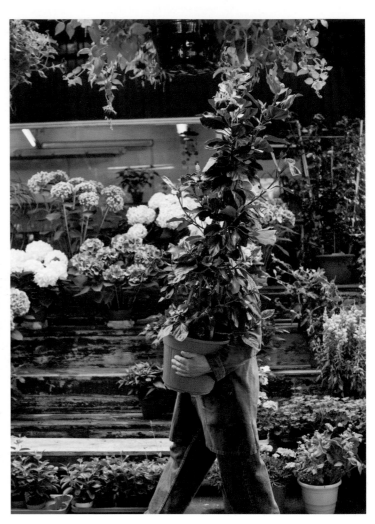

Orchids, fuchsias, baby tomato plants, window-box geraniums, herbs in little terracotta pots, a dozen blood-red roses for a Parisian lover...

... you name it, this historic flower market just footsteps from Notre Dame cathedral sells it.

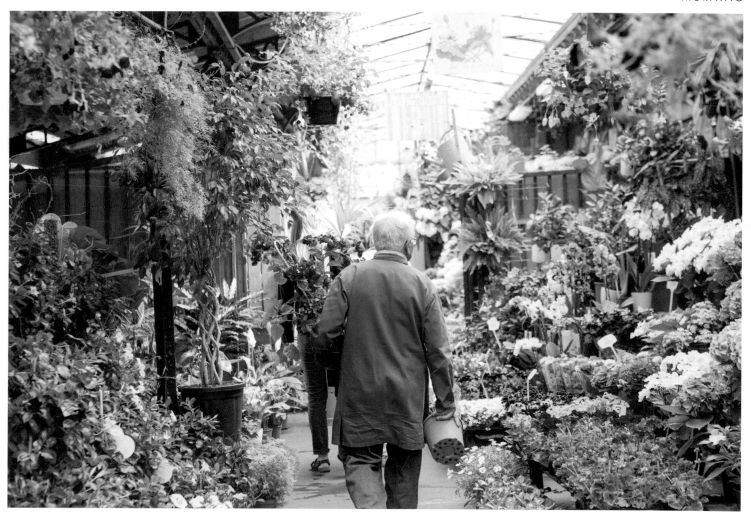

Flowers are a typical gift to bring to the host at a Parisian dinner party – but never lilies or chrysanthemums (reserved for funerals), white flowers (for weddings) or carnations (red signifies hate, other colours bad luck or bad will). And make sure your bouquet is in odd numbers, but never seven or 13.

'It's such a treat strolling around Paris in the early hours of the morning before the hot sun peers in-between the buildings and bounces off the cobbles. For me, these few minutes before the rest of Paris wakes up feel like going back in time. While the bakeries are just opening their doors, tourist attractions like the Arc de Triomphe still glow in the morning light. Suddenly, they don't feel like an attraction or big crowd-packed sight any more, but just another natural part of the beautiful city, like the lamp posts or cobbles.'

- *River Thompson*

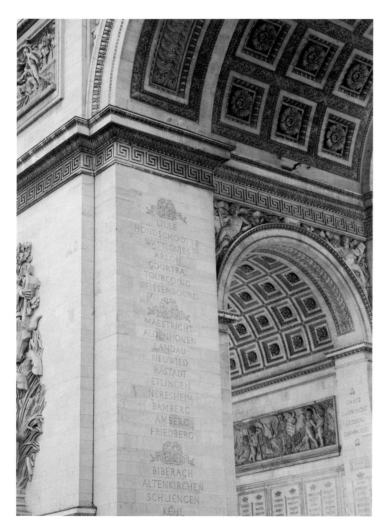

Place Charles de Gaulle is pierced by the heavily sculpted Arc de Triomphe, big enough to fly a plane through (as done in 1919).

On one of its pillars is La Marseillaise, a sculptural group depicting the civilian volunteers who marched from Marseille to Paris in 1792 to fight against Austria.

Once a patchwork of farms and windmills, and Edith Piaf's old stomping ground, the staunchly working-class *quartier* of Belleville buzzes quietly behind the scenes with some of the city's most groundbreaking craft breweries, hipster coffee roasters and innovative art projects.

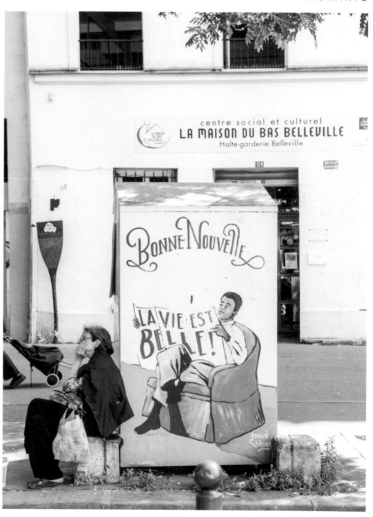

Artwork by TOQUÉ FRÈRES

Privy to some of Paris' best street art, panoramic views and a burgeoning food scene, Belleville is an off-the-radar slice of Paris worth checking out. It wasn't always so; in the Middle Ages it was in Belleville – then outside the city walls – that traitors, criminals and murderers were hanged and their strung-up corpses left to rot.

0900: Stall-holders shout out loud to flog their wares in a din of different languages at the raucous open-air food market Marché de Belleville. Its stalls have filled busy thoroughfare Boulevard de Belleville every Tuesday and Friday morning since 1860, and it's known throughout Paris as the city's cheapest market.

For the best bargains, shop around 2pm, just before the market closes. And if you want to check out the city's developing foodie scene, the fortnightly Thursday night food market offers about 15 stalls selling cooked food from around the world, which can be eaten at one of the communal tables or taken away.

Shopping for fruit, veg, freshly butchered halal meat, Indian spices, Tunisian couscous et al at Marché de Belleville is a fantastic entry into the vibrant community surrounding it, a multicultural melting pot of artists, students and immigrants from Africa, Asia and the Middle East since the 1960s.

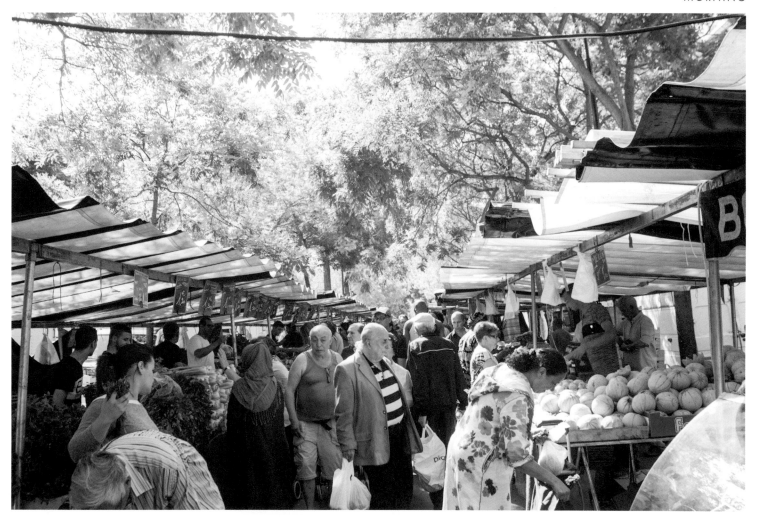

Stalls spread along the boulevard are piled high with seasonal produce, including *champignons de Paris*. Grown in abundance in the city's catacombs from the 17th century until the 1960s, the white button mushrooms are making a comeback as urban farmers find a demand for the fruits of their agricultural efforts.

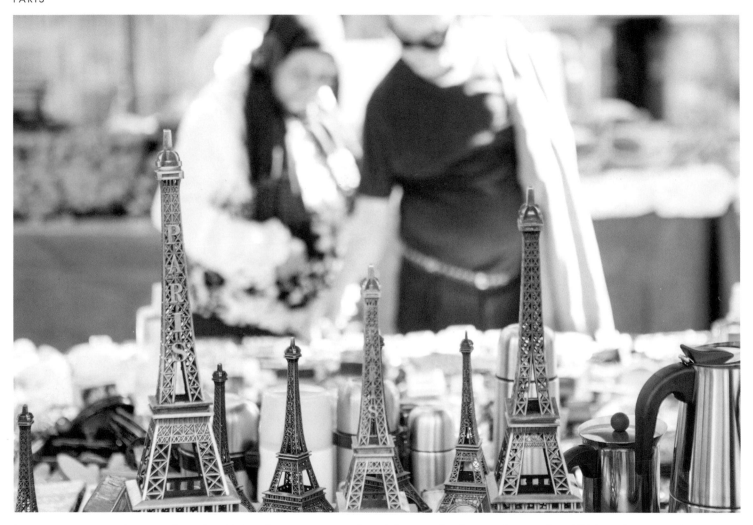

In a city synonymous with iconic sights and world-class shopping, souvenirs abound. Street vendors flogging cheap-as-chips Eiffel Tower key rings and 'Paris, je t'aime!' t-shirts can be found throughout the Belleville market and, come to that, almost every other market across the city.

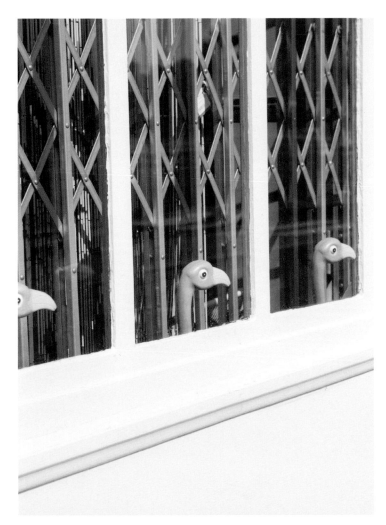

The popular pink pelicans in the window brighten up the yellow facade of Antoine et Lili and welcome vintage fans into its cornucopia of wares.

This Parisian fashion house sells ethical urban designs for women (pink store), children (green store) and vintage-inspired home decorations (yellow store).

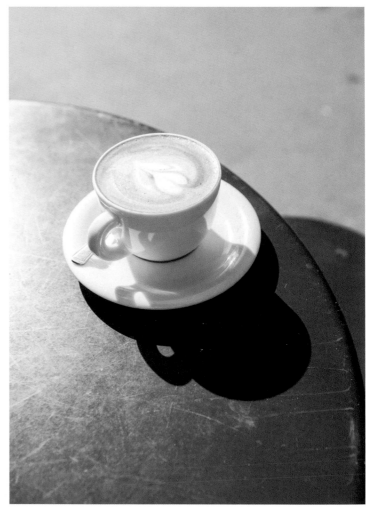

Tag-laced Canal St-Martin, inaugurated in 1825 (and funded by a tax on wine), is the cool place to picnic, promenade and play in eastern Paris.

Paris' traditional *café de quartier* (neighbourhood cafe) is reinvented at Craft, a specialist coffee shop and co-working cafe on Rue des Vinaigriers.

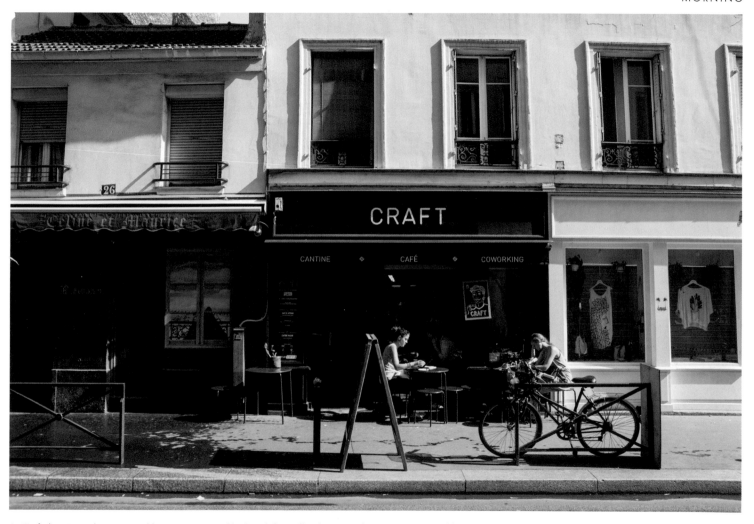

At Craft, boutique shoppers and laptop warriors alike break for coffee between shopping sprees and business appointments in the surrounding Canal St-Martin area. This *designer espace de coworking* (co-working cafe) is a rampant breed in 21st-century Paris – today's 'Hemingway hangout' for contemporary creatives.

Step through the door at belle époque bakery, Du Pain et des Idées, and swoon at a chandelier-lit interior dating back to 1899.

Marianne – symbol of France – stands tall on Place de la République, a square where Parisians traditionally gather to protest and make themselves heard.

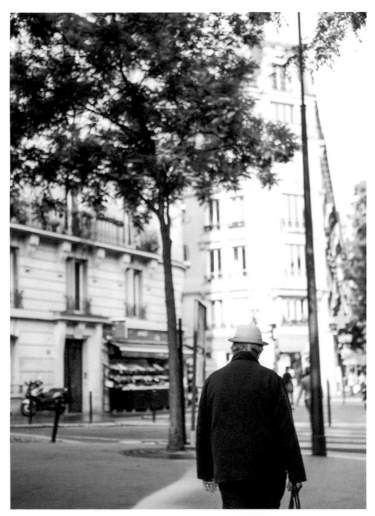

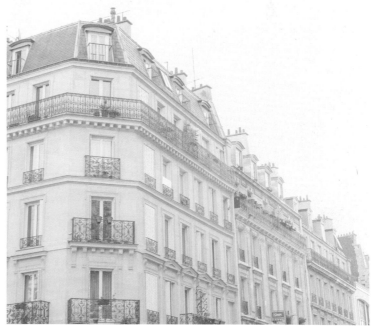

Strolling the length of Rue Custine (named after a militant general guillotined in 1793 on Place de la Concorde) is a wander through Haussmannian architecture.

Following rules created by Baron Haussmann during his rebuilding of medieval Paris from 1853, buildings on the long, wide boulevard are five storeys high.

1000: Cafe culture is fabled in Montmartre, a quaint hilltop neighbourhood in northern Paris that was made famous in the late 19th and early 20th centuries by the high-life hijinks of brilliant penniless painters such as Claude Monet, Picasso, Toulouse-Lautrec and Van Gogh.

'Coffee, although it may seem cliché, is a huge part of Paris to me, especially in the morning. The city's little corner cafes are *the* place to wake up, catch up, or just sit and watch the world go by. It is really special retreating to a cafe for coffee after waking up for a sunrise shoot, or even just perching for five minutes to plan the day ahead. La Halte du Sacre Coeur, on the corner of Rue Becquerel and Rue Curstine, was my spot in Montmartre for morning coffee. It took me just two days to get to know the names of locals found there every morning at 8 o'clock. Eric Didier (in photo) is one of them.'

- River Thompson

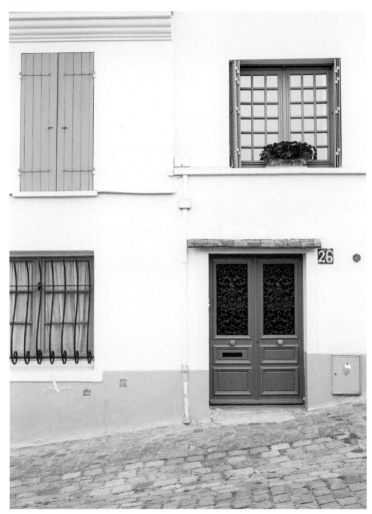

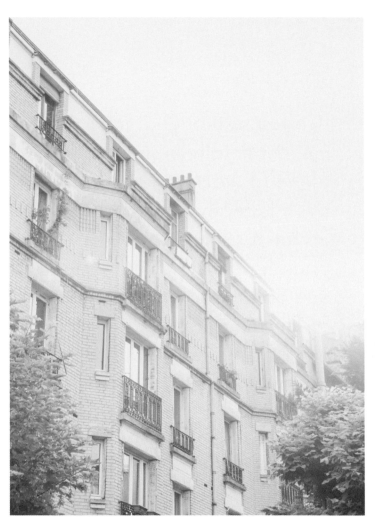

Ancient stone-paved lanes stagger at impossibly steep gradients up la butte, the 130m-high hill on which Montmartre sits.

Originally outside the city limits, covered in vineyards and dotted with windmills for making flour, la butte only became part of Paris in 1860.

Paris' only remaining vineyard, Clos Montmartre, produces up to 1000 bottles of wine a year from more than 25 different grape types, on vines planted in 1933.

Artists, bohemians, revolutionaries, can-can girls, headless martyrs and urban vignerons have all played their part in the fabulous history of Montmartre.

31

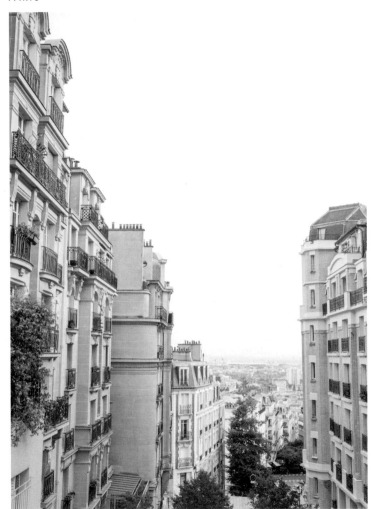

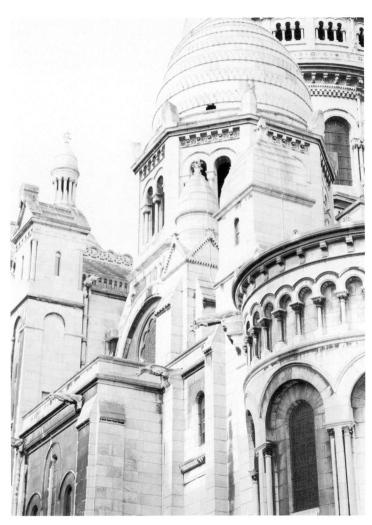

Montmartre's Rue du Mont-Cenis is aptly named after a peak in the French Alps: the medieval stone-paved street (broken by vertiginous steps) is alpine steep.

The pearly white Basilique de Sacré Coeur was built in 1874 to put the mojo back into Paris' spiritual health in the wake of France's humiliating defeat by Prussia.

Parisian street artist Invader (b 1969) has been at work in the city since the late 1990s. No two of his ceramic-tile mosaics, featuring pixelated characters inspired by those from early 8-bit video games of the 1970s and 1980s, are alike. Amazingly, only a select few know who the incognito artist is.

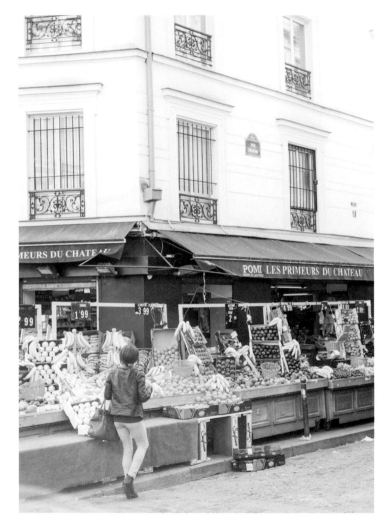

Given the French obsession with food, it is only right that every *quartier* has its own stash of small independent food shops.

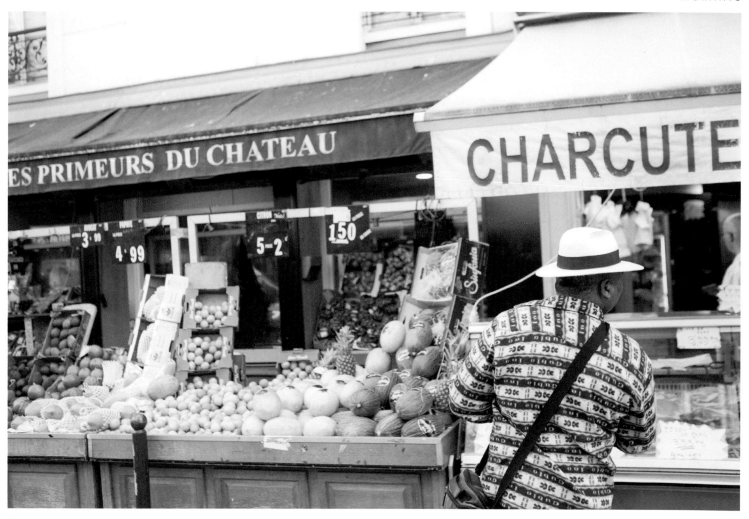

Staples include a *boulangerie* (bakery), a *boucherie* (butcher) and a fruit and veg shop selling fresh produce purchased earlier that morning at Marché de Rungis, the largest wholesale food market in the world, located on the outskirts of Paris.

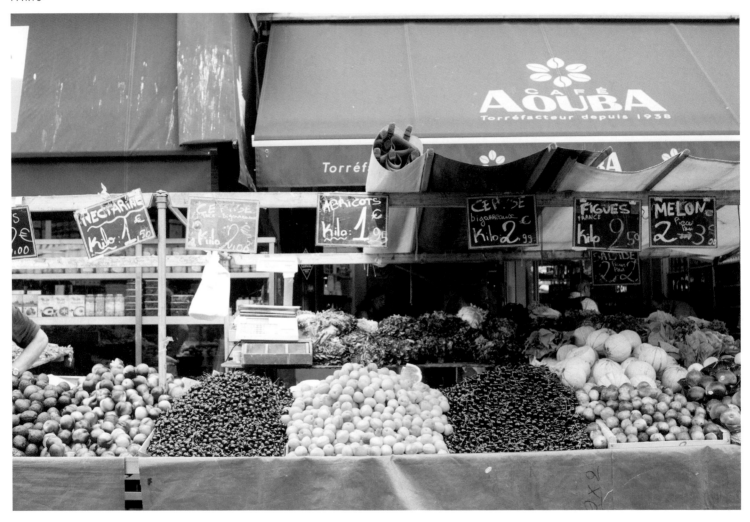

1100: Chaotic street market Marché d'Aligre is among Paris' most local and atmospheric food markets. Stalls selling fruit, veg, herbs and spices pack out Rue d'Aligre and adjoining Place d'Aligre from 8am to 1pm Tuesday to Sunday. Fortify yourself with strong, smokey, dark-roasted coffee at local roaster Café Aouba.

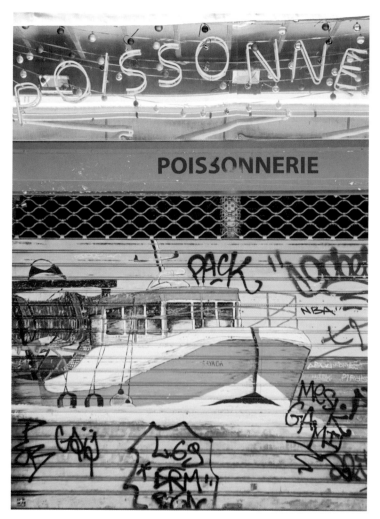

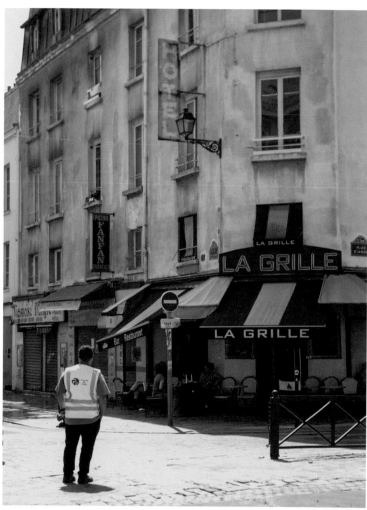

In eastern Paris, a short walk from Bastille, Rue d'Aligre and Place d'Aligre are foodie heaven. Poissonnerie d'Aligre is one of a trio of fishmongers there.

La Grille on Place d'Aligre is the original *bar du marché*, where stallholders pile in from 5am for coffee and warming toddies of its famous mint tea.

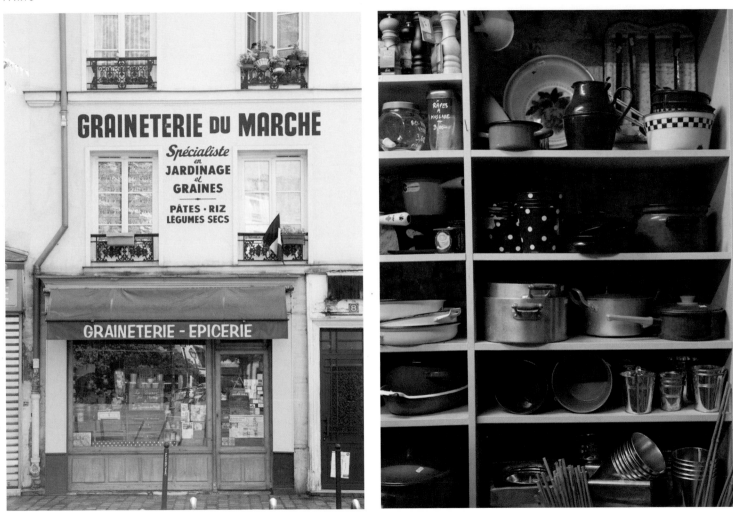

GRAINETERIE DU MARCHÉ

Spécialiste en JARDINAGE et GRAINES

PÂTES · RIZ LÉGUMES SECS

GRAINETERIE - EPICERIE

A rite of passage for gourmets is a delicious visit to José Ferré's La Graineterie du Marché, an old-fashioned grocery on Place d'Aligre. Paris' last *graineterie* (grain shop) overflows with oils, vinegars, bottles of artisanal lemonade, tins of Breton sardines, household goods and an exceptional choice of grains, flours and seeds.

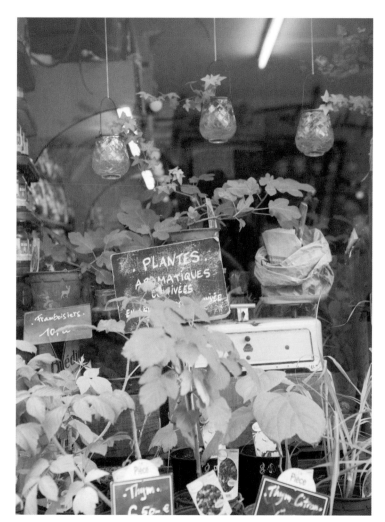
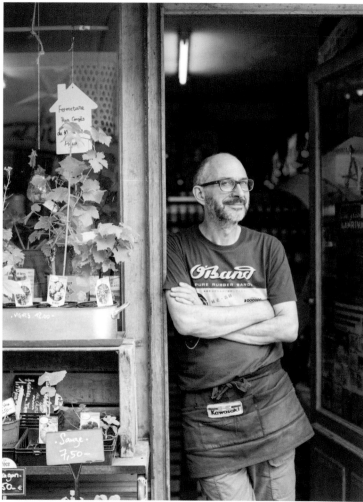

Outside, fresh herbs and aromatic plants spill out of the shop and scent the air around the oldest store in the neighbourhood. Jams, chutneys and honeys are some of nature's other bounties sold inside.

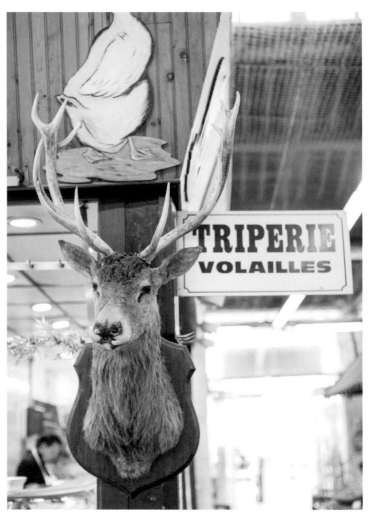

Hidden between market stalls on Rue d'Aligré is historic covered market hall Marché Beauvau – a favourite weekend shopping destination since 1843.

Parisians shop for poultry, rabbit, hare, seasonal game and, of course, tripe at Au Chapon d'Aligre, a busy butcher's stall signposted by a pair of antlers.

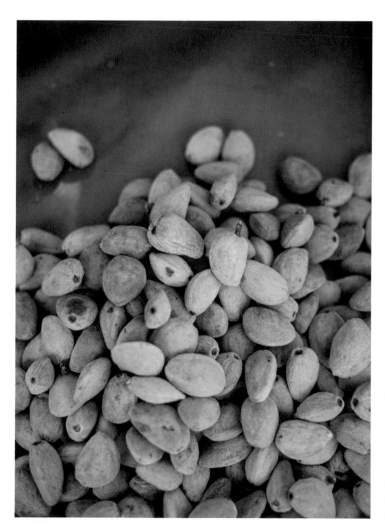

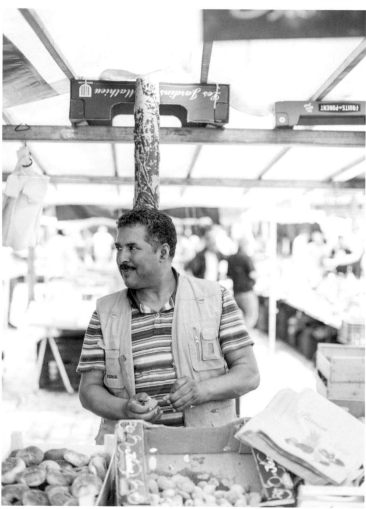

Shopping for seasonal produce, olives, fresh almonds, spices, cured meats, cheeses and other food at the morning market is a way of life for Parisians.

Each *quartier* has its own market that springs to life a couple of days a week. Bring your own shopping bag.

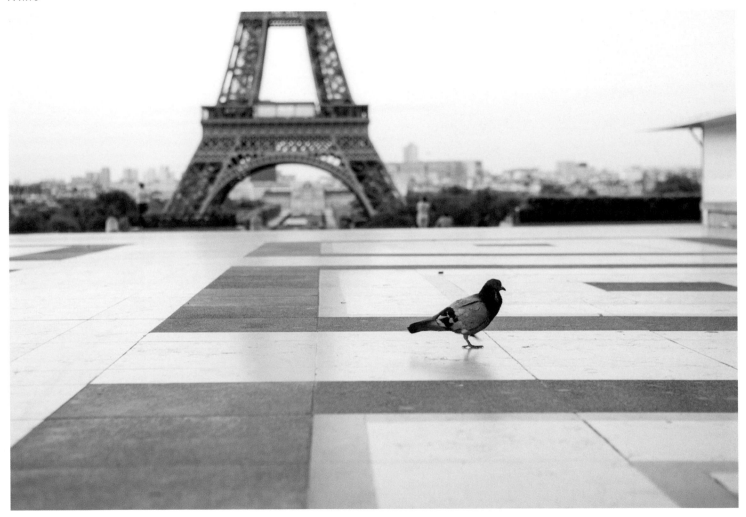

Pigeons have long been considered a pest in Paris. City authorities reckon there are around 80,000 in all – one pigeon for every 25 Parisians. Feeding them can incur an on-the-spot fine of €68. The Summer Olympics in Paris in 1900 were the only Games to include live pigeon shooting as an event.

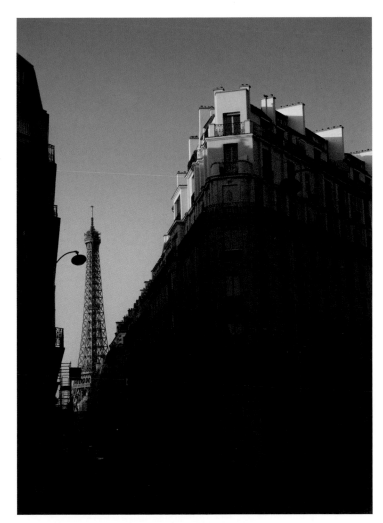

Mademoiselle playing peek-a-boo, framed by the signature Haussmannian buildings, big windows, elegant wrought-iron balconies et al.

They may be pests today, but during the city siege of the Franco-Prussian War (1870), pigeons were the only means of communication with the outside world.

Views from the top of the Eiffel Tower – the tallest man-made structure in the world when it was unveiled in 1889 – can reach 60km on clear days.

Parisians are viewed as litter bugs. In anticipation of the 2024 Olympic Games, city mayor Anne Hidalgo has pledged €22 million for street-cleaning equipment.

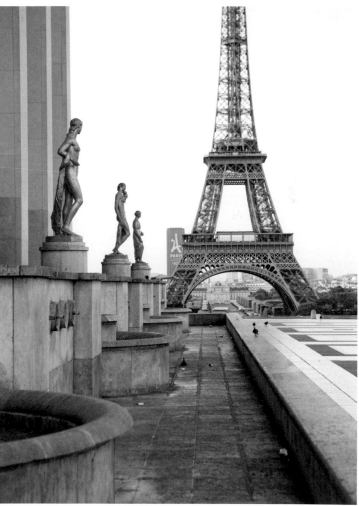

In 1948, the UN adopted the Universal Declaration of Human Rights at Palais de Chaillot, over the water from the Eiffel Tower. The glittering statues on Esplanade des Droits de l'Homme outside the palace represent eight allegorical figures: Youth, Flowers, Morning, Countryside, Birds, the Gardener, Spring and Fruits.

Guy de Maupassant famously hated the tower so much he ate at its base every day so he didn't have to look at it; the rest of the world can't get enough of it.

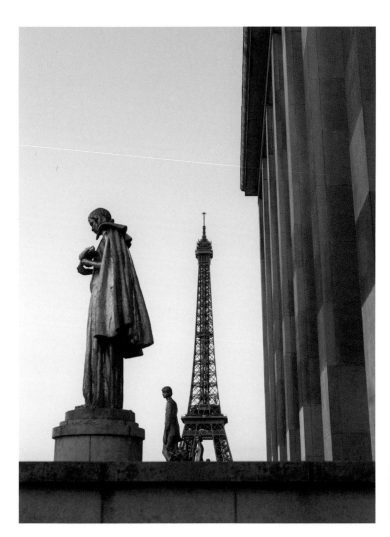

One of the most spectacular views of the Eiffel Tower is from the south-facing terrace of Palais de Chaillot, a neoclassical palace on the right bank. Built in 1937 for the Universal Exhibition, its monumental interior today houses three museums, a restaurant and a theatre.

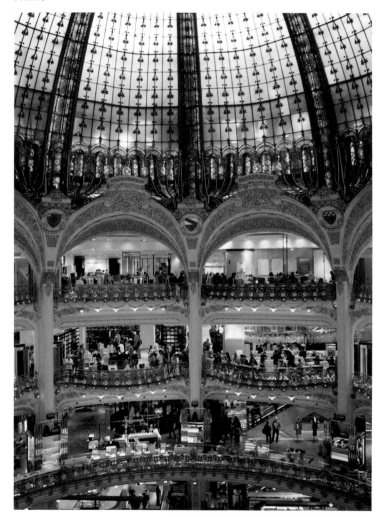

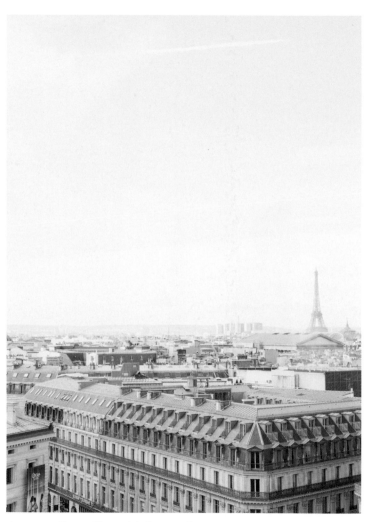

Iconic Galeries Lafayette is the second-most visited address in Paris after the Eiffel Tower. Its show-stealing Art Nouveau architecture dates to 1912.

Atop seven floors of beautiful objects to buy is La Terrasse, with olive trees, deckchairs, a telescope and a most exceptional city panorama – all for free.

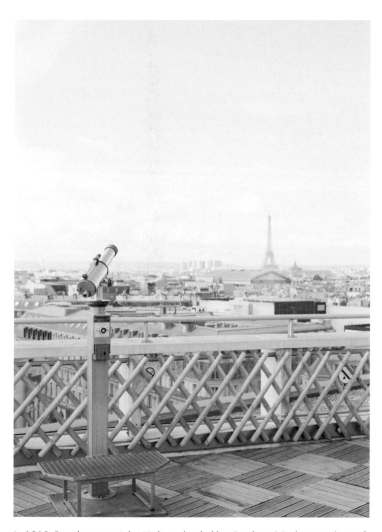

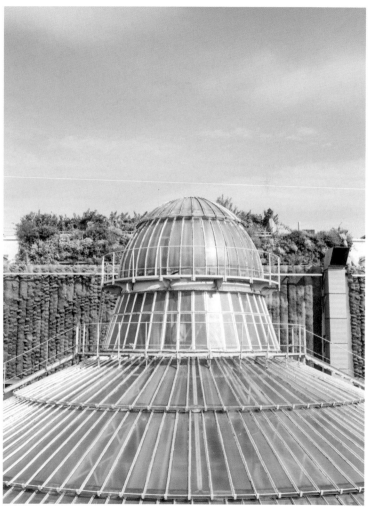

In 1919, French aviator Jules Védrines landed his Caudron G3 plane on the roof. He was fined for doing so, but become the first air offender in aviation history.

Galeries Lafayette began life in 1893 as a tiny (70 sq metre) haberdashery store. Now its central hall is capped by a 43m-high Art Nouveau cupola.

In 1912, master glassmaker Jacques Grüber was commissioned to hand-craft the dazzling mirage of coloured stained glass inside the cupola dome. A century later, in 2012, its glorious Neo-Byzantine good looks were enhanced with designer lighting by French conceptual artist Yann Kersalé.

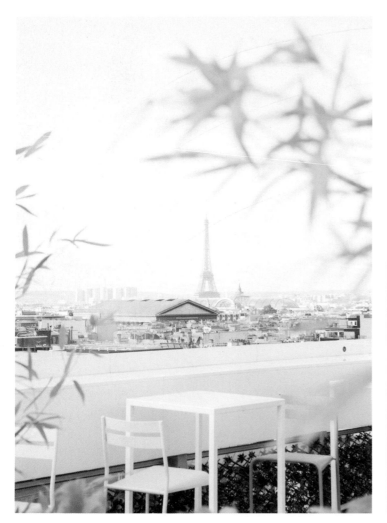
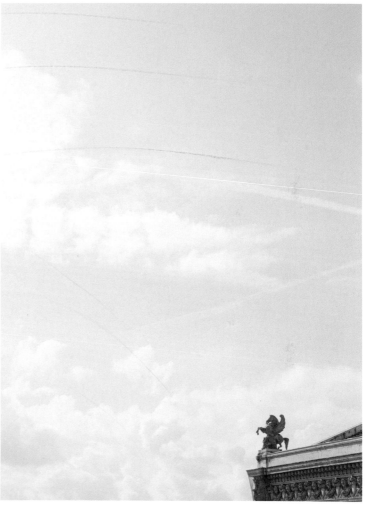

The sweeping, 360-degree view from windswept La Terrasse takes in the Eiffel Tower, Montmartre and, closer to home, the splendours of the opulent Palais Garnier opera house, with its twinkling gilt figures of Harmony and Poetry by Charles Gumery and the bronze Pegasus statues by Eugène-Louis Lequesne.

No Parisian *quartier* has more flights of stairs than Montmartre. If the 300 steps are *de trop*, ride the funicular, water-powered when it opened in 1900.

Apartment living is de rigueur in Paris – 96.7% of residents live in an apartment, most typically a tiny studio or slightly larger space with two rooms.

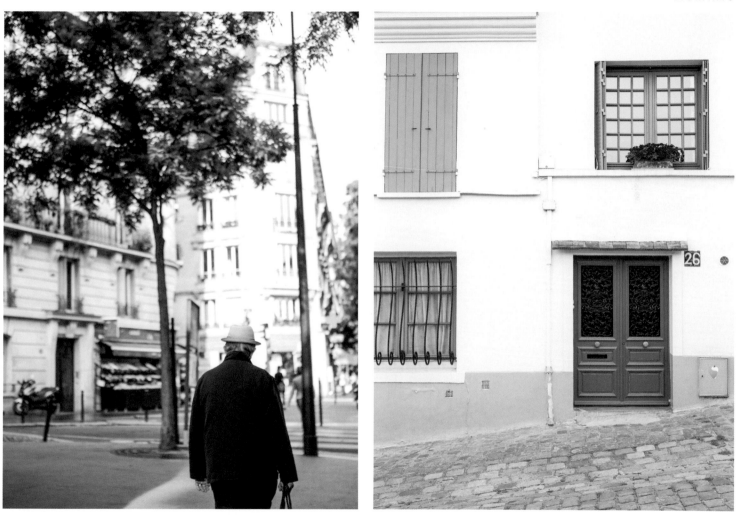

Duck down Rue de la Vieuville to catch the contemporary face of this mythical artists' *quartier*: Nikolas Serdar runs art workshops at No 17 and there's ample ephemeral street art to view. It was here that artists Toulouse-Lautrec, Paul Signac, Utrillo et al came to get their pictures framed at the famous Anzoni workshop.

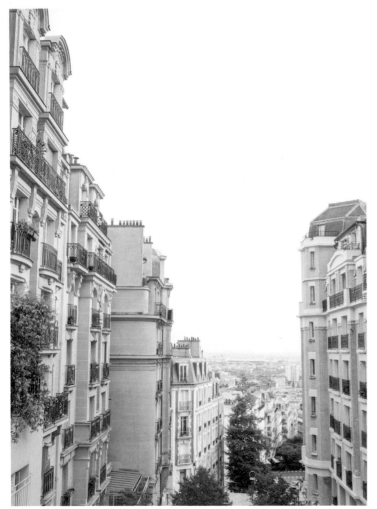

There's far more to Montmartre's iconic Basilique du Sacré Coeur than lofty dove-white domes and blockbuster city views. Leave the crowds behind to discover its backyard, complete with a contemplative water garden with fountains, and tranquil spots designed with quiet meditation in mind.

From 1910, Pablo Picasso frequently dined at La Maison Rose in Montmartre.
Femme fatale owner Germaine Gargallo modelled for several of his portraits.

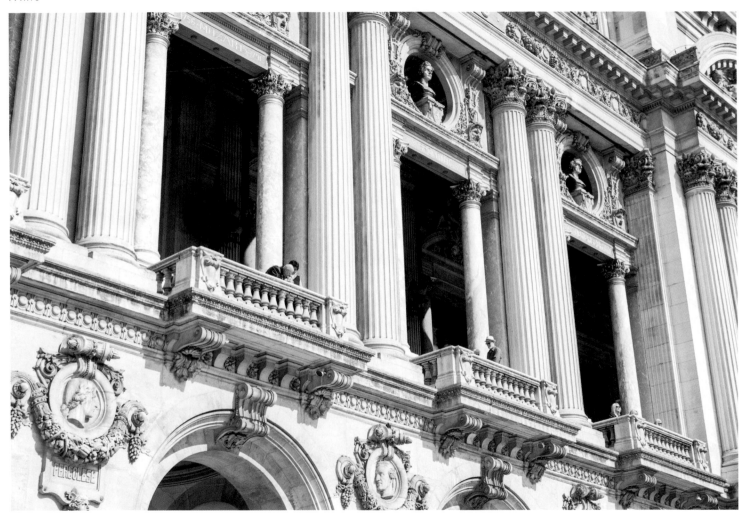

Charles Garnier's neo-Baroque Palais Garnier opera house opened with much fanfare in 1875. Its colourful and often sinister history inspired Parisian detective writer Gaston Leroux to pen his Gothic love story, *The Phantom of the Opera,* in 1910 (subsequently made into the 1986 Andrew Lloyd Webber musical).

Palais Garnier was built on a swamp and still has a large water tank beneath it which is used as a training ground by Paris firemen. In 1896, a worker was killed after one of the counterweights suspending Garnier's showpiece chandelier – seven tonnes of glittering bronze and crystal – crashed down onto him.

Motorists new in town might well struggle to get their bearings around Place de l'Europe in the 9e. Created as part of the Quartier de l'Europe urbanisation project from 1826, streets here are named after other European cities: Rue de Vienne, Rue de Madrid, Rue de Lisbonne, Rue de Bruxelles and so on.

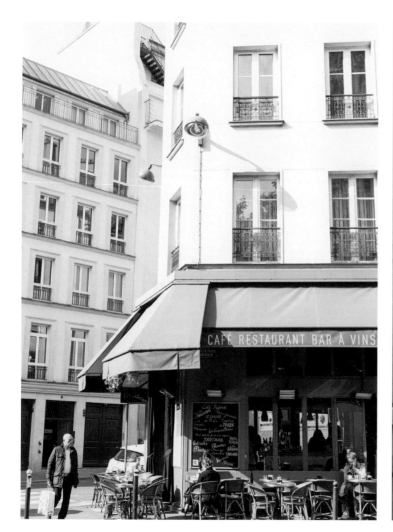

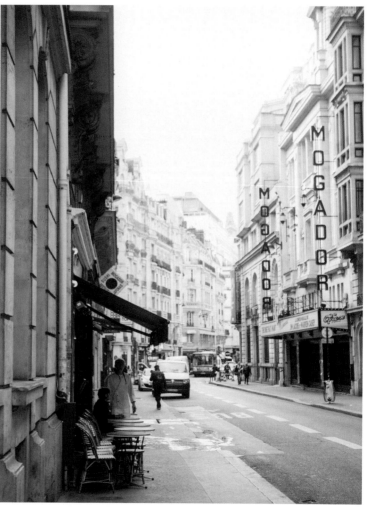

1200: On Rue de Londres, locals gravitate to Café Vert Tulipe, a quintessential Parisian cafe with chairs perfectly positioned to catch the morning sun over a coffee and croissant. As in all Paris cafes, space is tight and chairs are placed with military precision; when you leave, put said chair back in line or risk the waiter's wrath.

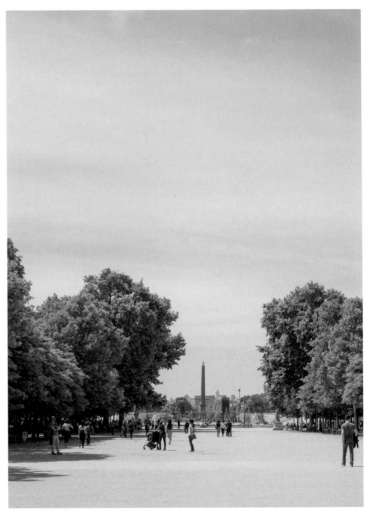

No single chair design screams 'Paris' louder than Fermob's famed Luxembourg, designed by the city's parks department for Jardin du Luxembourg in 1923.

60

Place de la Concorde's 23m-high obelisk, the city's most ancient monument at 3300 years old, came from Luxor in Egypt. It was presented to Paris in 1833.

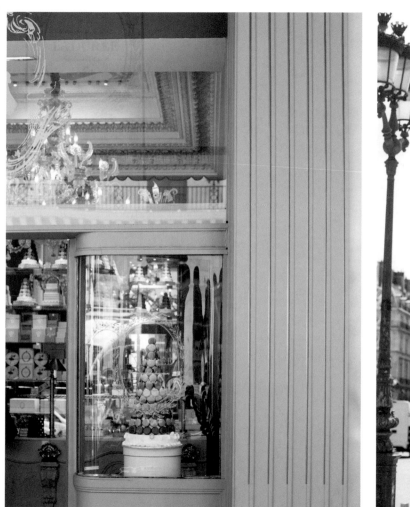

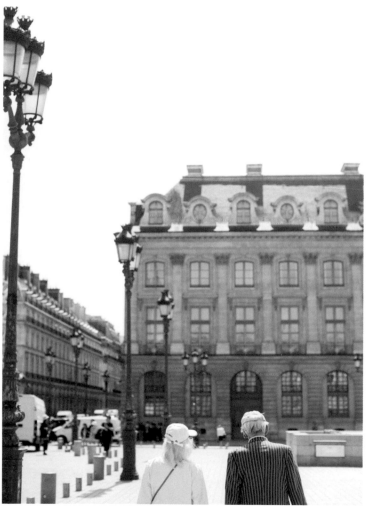

A peppermint-green box of lighter-than-air, ganache-filled macarons from Ladurée is the last word in gourmet chic. The pâtisserie opened in 1862 and created the city's signature cake in the 1930s. Its boutique on Rue de Castiglione, in the 1e, is a shopping-bag flick from the luxury jewellers of posh Place Vendôme.

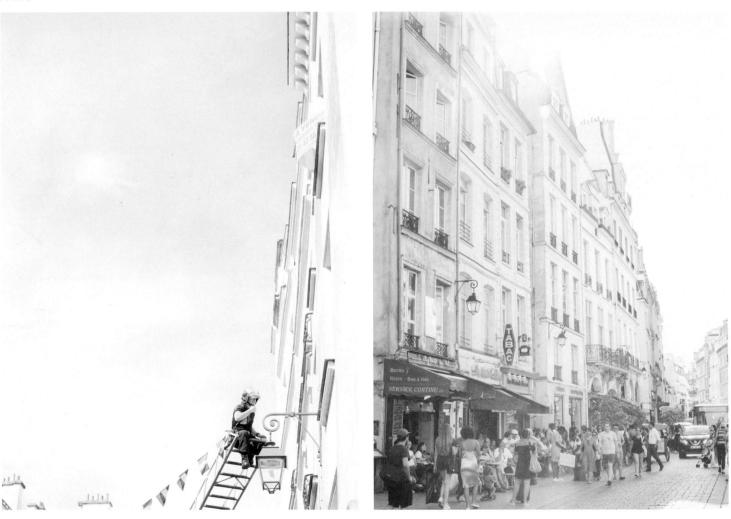

1300: The Marais district on the Right Bank squirrels away the last remnants of the colourful Jewish quarter Pletzl, abuzz with kosher grocery stores and takeaway falafel joints. It starts on Rue des Rosiers and continues along Rue Ste-Croix de la Bretonnerie to Rue du Temple.

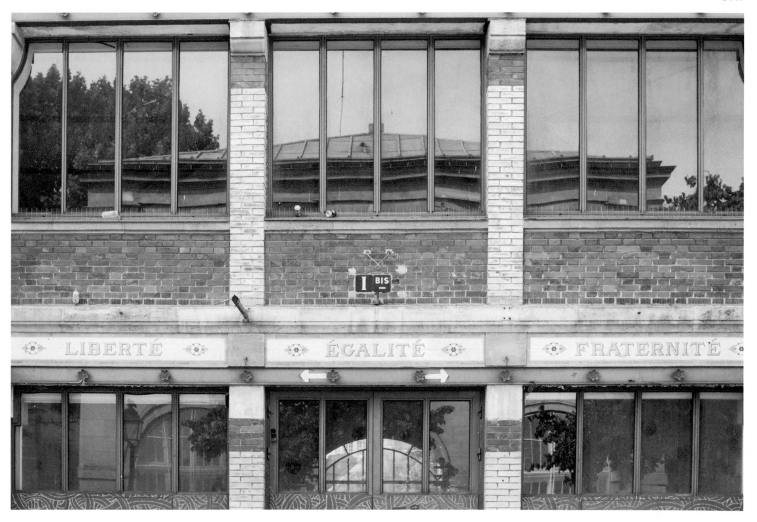

As the official national motto of France, 'Liberty, Equality, Fraternity' is plastered across many a school, city hall and public building in Paris. It was coined during the Age of Enlightenment, used as a warrior cry during the French Revolution and publicly inscribed in stone from 1880.

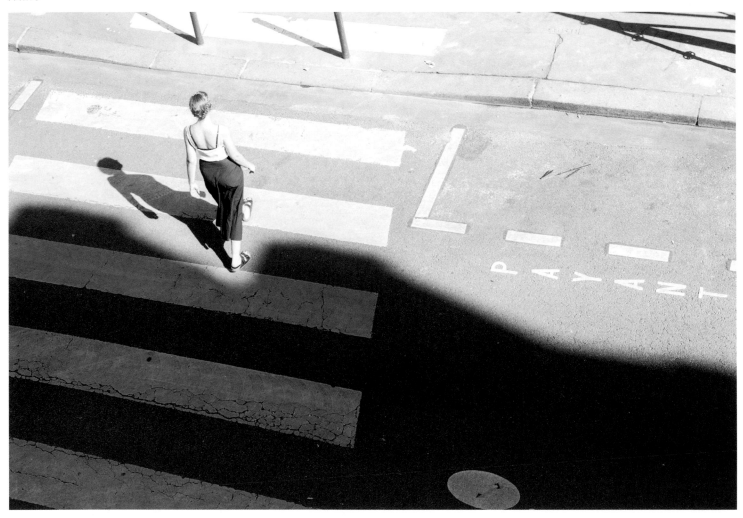

French designer Yves Saint Laurent once declared that fashion is a way of life, and most Parisians would agree – dressing effortlessly well is part of the Parisian DNA. All eyes are on the French capital twice a year when the world's top designers work the catwalks at Paris Fashion Week.

Eclectic and edgy, the 10e in northern Paris is a nose-dive into local life. Its main north-south artery is Rue du Faubourg Saint Martin, filled to bursting with artisanal wine bars, third-wave coffee shops and the odd cafe-pavement terrace.

The historically working-class 11e is today edgy, hipster and brimming with local soul. Feel its catchy heartbeat on Rue de Charonne.

Watch artists at work at Cours de l'Industrie. Its half-timbered buildings dating from the 17th century were reopened in 2017 after six years of renovation.

At Rue de Montreuil nearby, galleries and artist workshops fill La Cité d'Ameublement, another vintage address with an artistic heritage. In the 1930s this was where the city's cabinet and furniture makers had their workshops and little factories.

There's far more to Paris street art than tagged shop shutters. All over the city, yarn bombing or urban knitting jazzes up otherwise inconspicuous benches, staircases, even pavement cracks and trees. Place Léon Blum in the 11e is a fine starting point if you want to admire some of the city's public art projects.

Give a bunch of Parisian men a gravelly neighbourhood square and within seconds a traditional game of pétanque will unfold on the rough sand. The ball closest to the *cochonnet* ('piglet' or jack) wins. Paris' oldest pétanque pitch is at Arènes de Lutèce, an ancient circular Roman amphitheatre in the 5e.

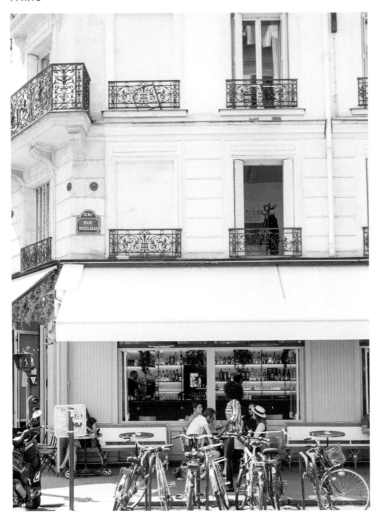

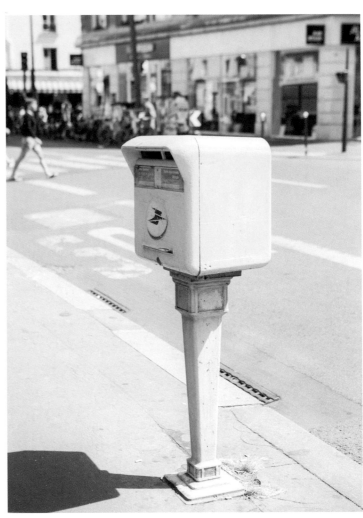

Mayor Anne Hidalgo is working hard to make Paris a world-class city to cycle in – 5% of all journeys are by bike, but she's aiming for 15% by 2020.

In 1653, Paris became the first European city to sport post boxes. It was not until the 1820s that the canary-yellow containers spread to the rest of France.

One of the rowdiest bar-hopping streets in Paris after dark, quaint *Rue de Lappe, 11e*, is worth wandering by day. Immigrants from Auvergne arrived in the 19th century and opened *cafés-charbons* – cafes also selling coal – and the street soon became a popular drinking strip, famous for its accordion-driven dance halls.

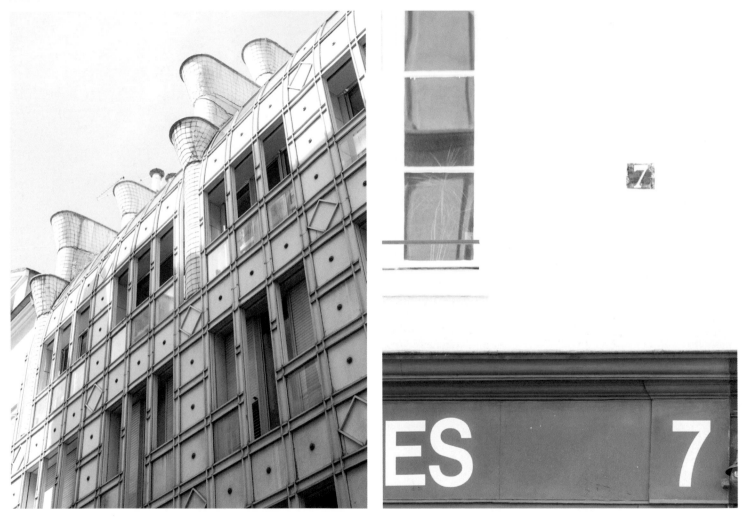

Rue de Lappe dates to the 17th century, but today its buildings are a mix of contemporary and ancient architecture. In the 1980s, postmodern Spanish architect Manolo Núñez Yanowsky designed several buildings in Paris, including an apartment block at 11 rue de Lappe.

Every *quartier* has its own veritable brasserie with entrecôte (steak), boudin (blood sausage), confit de canard (conserved duck breast) et al on the menu, as well as a hearty selection of French wine behind the bar and dark wood bistro chairs. Enter Café de l'Industrie on Rue Saint-Sabin in the 11e.

Afternoons here offer the lull before the storm. Come 1700, a post-work crowd will pile into Café de l'Industrie for glasses of kir (white wine and blackberry liqueur), pastis or simple *vin rouge* (red wine), as is required for that all-essential apéritif (pre-dinner drink).

Since France made smoking in enclosed public places illegal in 2007, every cafe has at least a couple of bistro tables outside to accommodate *fumeurs*, come rain, hail or sunshine – and Café de l'Industrie is no exception.

'It was pouring with rain and it must have been Thursday – the only day of the week that La Maison du Pastel is open. I instantly wanted to put my camera down and explore the rich palette of colours, and hear more about the history of this unique pastel shop. As the rain continually hammered down on the window, visiting this dimly lit shop was a true Parisian experience. Looking out onto the cobbled square, as Margaret Zayer slowly laid out hundreds of shades of pastels in their beautiful wooden trays, I felt like an artist from the 19th century.'

- *River Thompson*

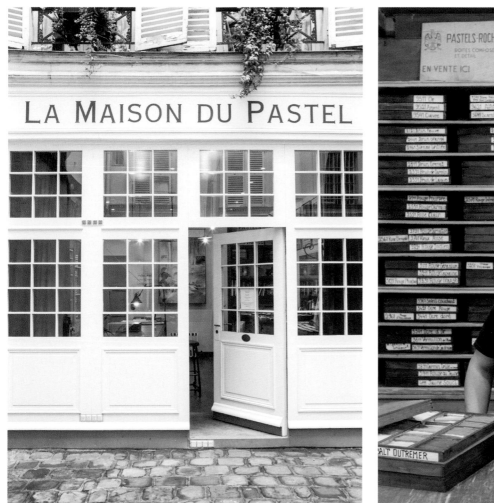

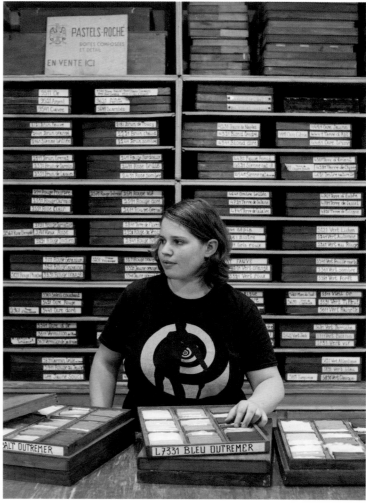

A block north of the Centre Pompidou, the world's oldest pastel manufacturer dazzles with a rainbow of colour – 1201 shades at the last count – at La Maison du Pastel in the 3e. Dating from 1720, it has supplied pastels to some of the world's greatest 19th-century painters, among them Degas, Manet, Millet and Sisley.

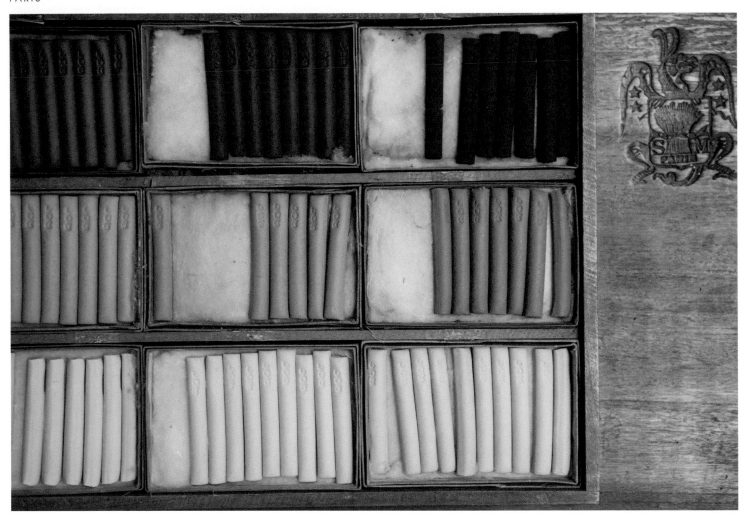

Parisian pharmacist Henri Roché bought La Maison du Pastel in 1865, and in 1912 the factory, workshop and shop moved to its current courtyard location off Rue Rambuteau; production moved to the cheaper suburbs in the 1930s. Today, Isabelle Roché, a distant relative, runs the shop with business partner Margaret Zayer.

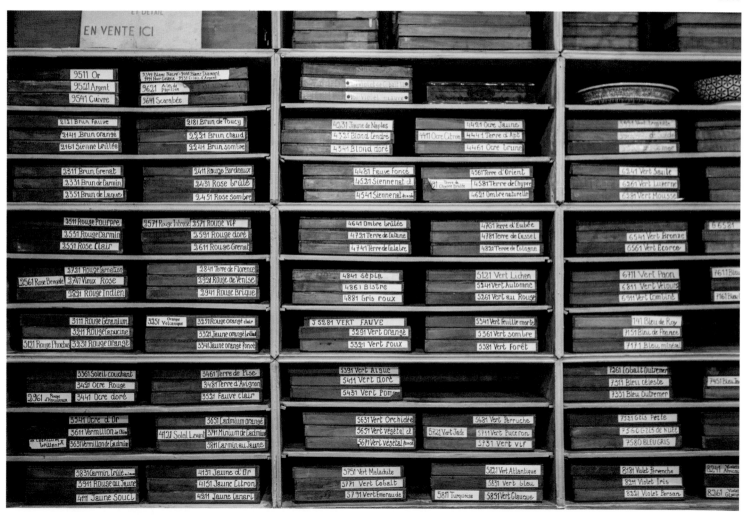

The enchanting Rue Rambuteau boutique sells handmade pastels in nuances of lake brown, geranium red, volcanic orange, tree-frog green and French blue, all of which are artist gold. The range is smaller than its early 20th-century peak of 1650 colours, but has more than doubled since Isabelle took over the business.

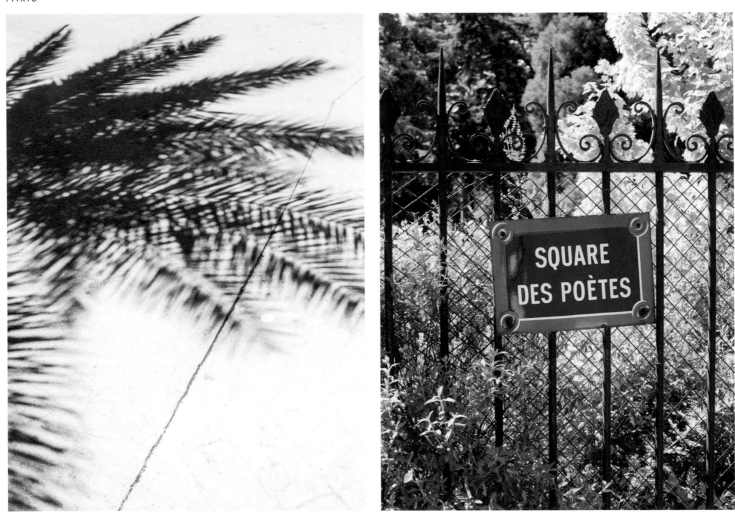

Paris street names tell tales (like the one of the cat that tried a spot of fishing during floods on Rue du Chat qui Peche in the 5e). In western Paris, Square des Poètes celebrates the theme of nature in French poetry. Forty-eight plaques along flowery paths on the tree-shaded square quote lines by different French poets.

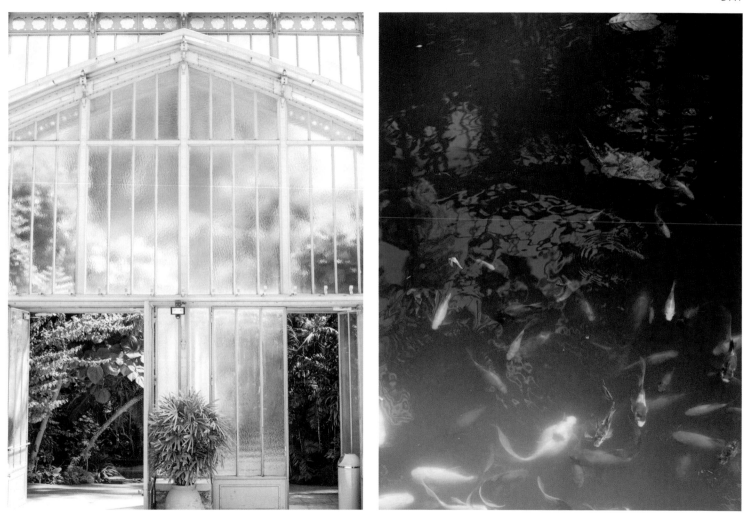

Steps away from Square des Poètes rise the antique hot houses of Jardin des Serres d'Auteuil – one of the city's 'secret' free attractions. Erected in 1898, the heated greenhouses are filled to bursting with gigantic palm trees, ferocious cacti, exotic blooms, an aviary and a fish pond teeming with Japanese carp.

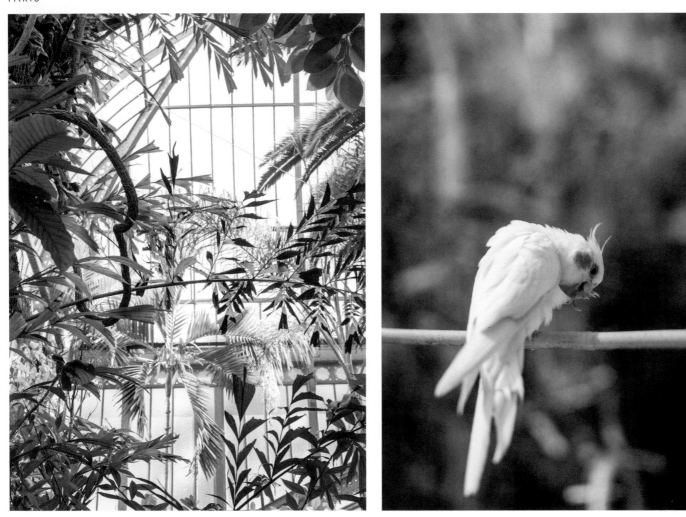

1500: Ever wondered where all the beautiful pot plants and flowers decorating municipal offices in Paris come from? They are grown in the greenhouses at Jardin des Serres d'Auteuil, where more than 100,000 plants per year are produced on a site that has served as a botanical garden for more than two centuries.

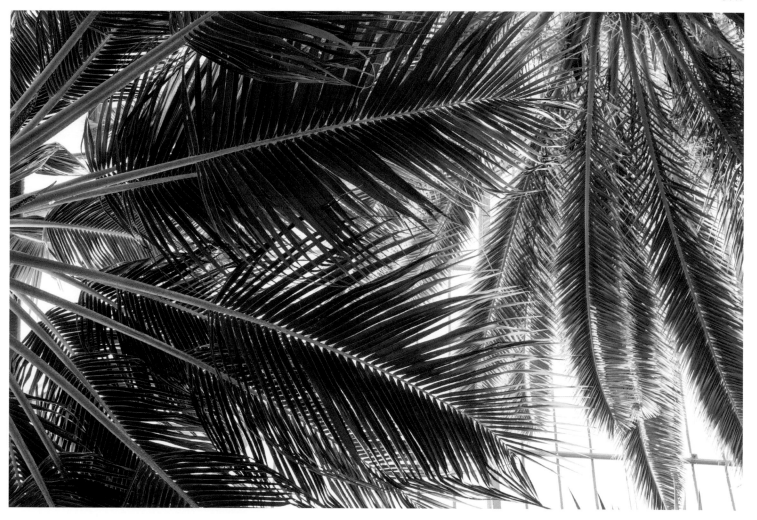

Enchanting and tropical in equal measures, the botanical garden sits on the southeastern fringe of Bois de Boulogne in western Paris and is one of the city's most Zen retreats. Beyond it, the Bois de Boulogne itself offers Paris' second-biggest park, modelled in part on London's Hyde Park.

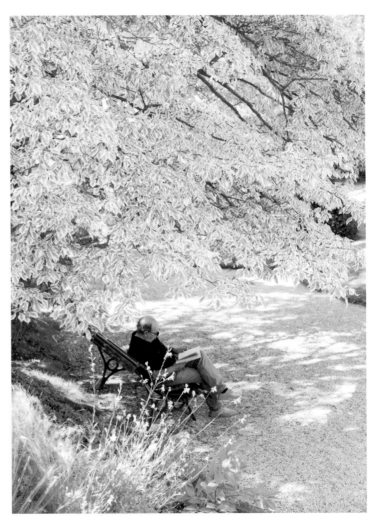

The greenhouses in the gardens were designed and constructed from 1895 to 1898 by architect Jean-Camille Formigé.

In 1852, Napoleon III asked city planner Baron Haussmann to completely re-landscape the ancient woodland of the vast Bois de Boulogne.

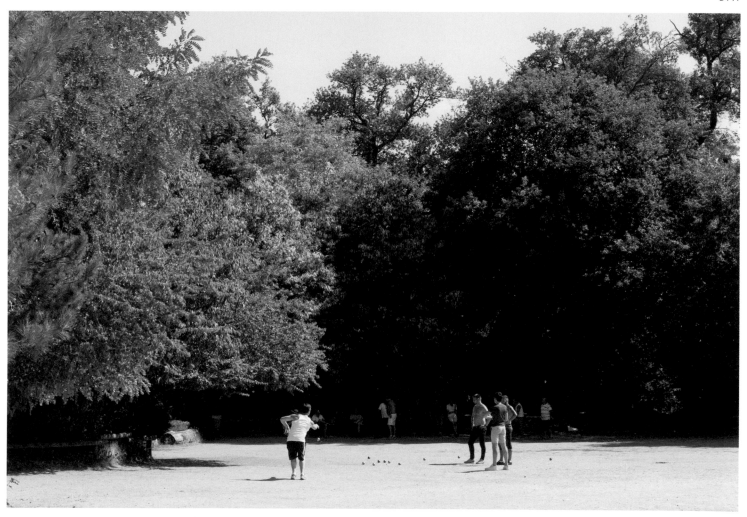

Haussmann ripped down the 16th-century wall surrounding the former royal hunting ground and planted 400,000 trees to create an open, airy space. Be it catching a game of French boules or a few rays of summer sun, Bois de Boulogne is the place Parisians go for weekend relaxation.

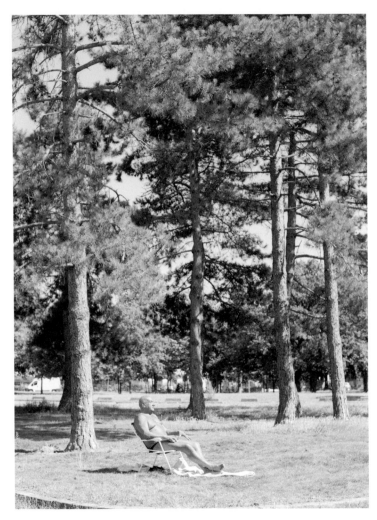

Monsieur Gomez enjoys basking in summer sunshine in the Bois de Boulogne.

'I wasn't sure about approaching the man sunbathing in skimpy Speedos in the Bois de Boulogne, a short metro ride from the centre of Paris. After much hesitation and back-and-forth debate with myself, I plucked up the courage and asked the sunbather if he would be up for a little chat and a portrait perhaps. Monsieur Gomez is as Parisian as it gets. On warm weekends he retreats from the hustle and bustle of the big city to the green Bois de Boulogne where he immerses himself in the joys of the 'countryside' while keeping one eye on his city, forever visible in the form of the tip of the Eiffel Tower squatting between trees on the horizon.'

- River Thompson

Bois de Boulogne is one large playground. The gargantuan park ensnares lakes, grottoes and horse-racing tracks, as well as an amusement park, the 18th-century Château de Bagatelle, an open-air theatre and a romantic garden planted with flowers and trees, referenced in plays by William Shakespeare.

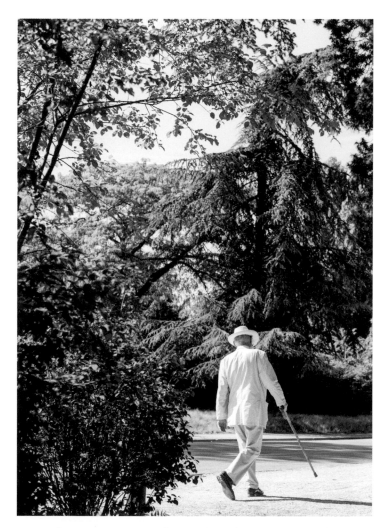

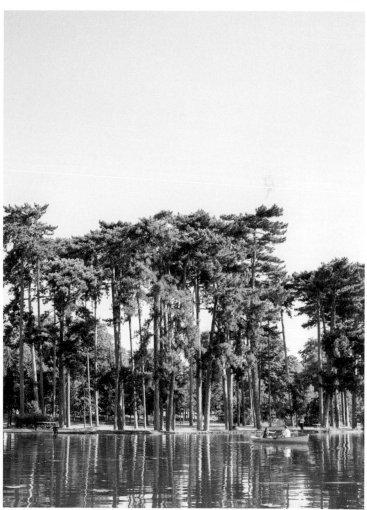

Promenading or rowing romantically around Bois de Boulogne's Lac Inférieur were aristocratic pastimes in the 19th century but hoi polloi stuff today. On one of the lake's two artificial islands is restaurant Le Chalet des Îles, a real Swiss chalet shipped to Paris by Napoleon III as a gift for Empress Eugénie, whom he wed in 1853.

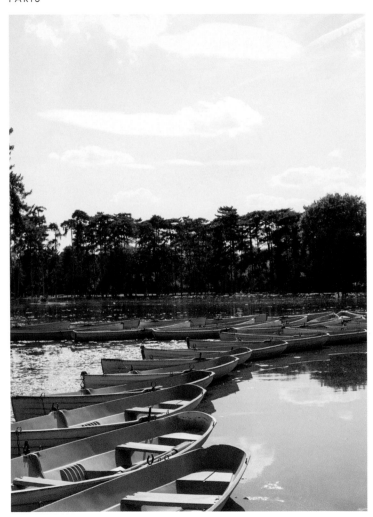

In the 19th century, the romantic scenes of Parisians at work and play in the Bois de Boulogne captured the imagination of the Impressionists. Renoir famously painted Parisians skating on a frozen lake here in 1868, and Impressionism's female pioneer Berthe Morisot painted dozens of Bois de Boulogne scenes.

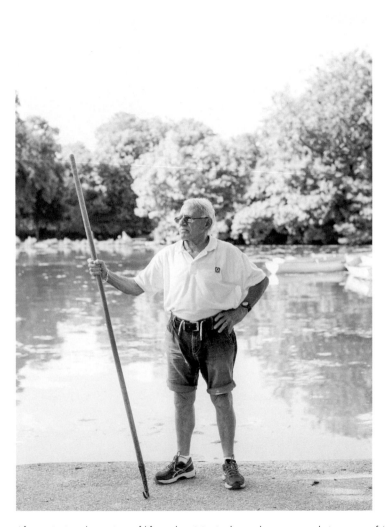

After enjoying the variety of life and activity in the park, you can admire many of Morisot's depictions of it – among them oil paintings, watercolours and pastels – in the Musée Marmottan Monet (alongside the world's largest collection of Claude Monet paintings). It's set in an old hunting lodge on the park's eastern fringe.

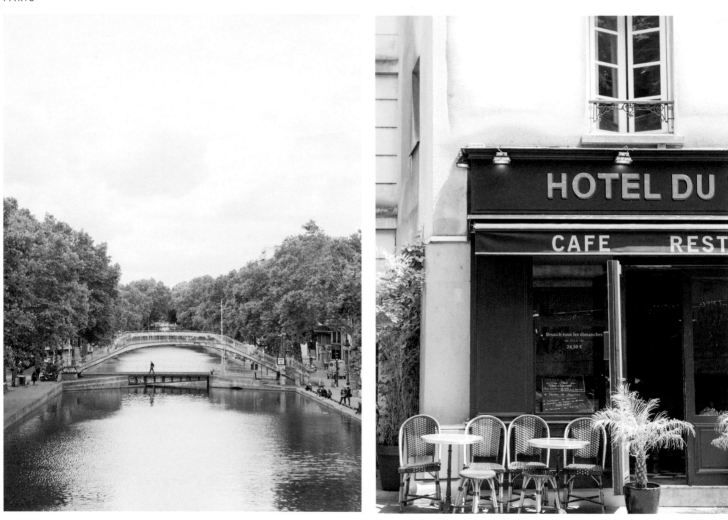

The tranquil, 4.5km-long Canal St-Martin had a dual purpose when it was completed in 1825; as well as creating a shipping route into the city, it supplied Paris with fresh water. From the footbridge by the intersection of Rue de la Grange aux Belles and Quai de Jemmapes, watch the old road bridge swing open for narrowboats.

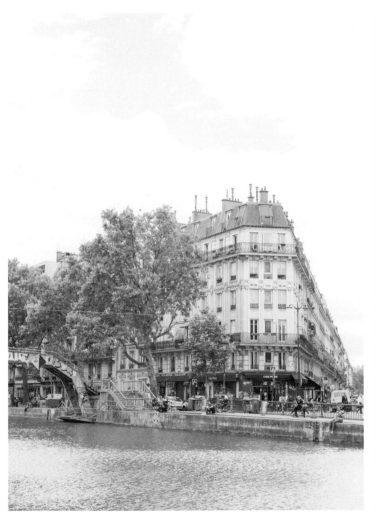

The banks of Canal St-Martin are a hotspot among Parisians and tourists alike, who come here for romantic strolls, bike rides, picnics and dusk-time drinks at the waterside bars and cafes. When the canal was cleaned in 2016, 100 bikes, a toilet, bathtub and ski boot were among the unexpected objects found.

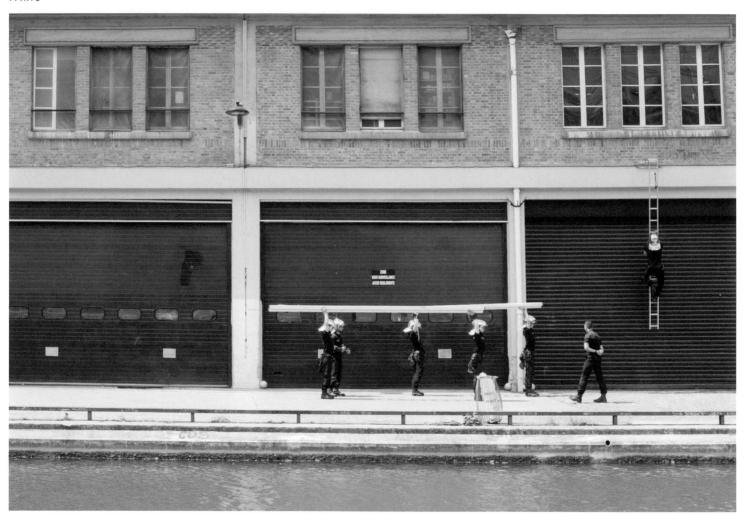

The *sapeurs-pompiers de Paris* (firemen) are national icons. Known for their smouldering good looks (buy the calendar) and physical prowess, they are the elite of the country's fire fighters. Unlike other brigades nationwide, theirs is a 8550-strong military unit in the French army.

Parkour, or free running, was born in the French military and became an urban sport in the Parisian suburbs in the 1980s. Rooftops are the main terrain of its practitioners – *traceurs* – who traverse the city via bridges, buildings and walls by swinging, climbing, jumping and running in the most efficient manner possible.

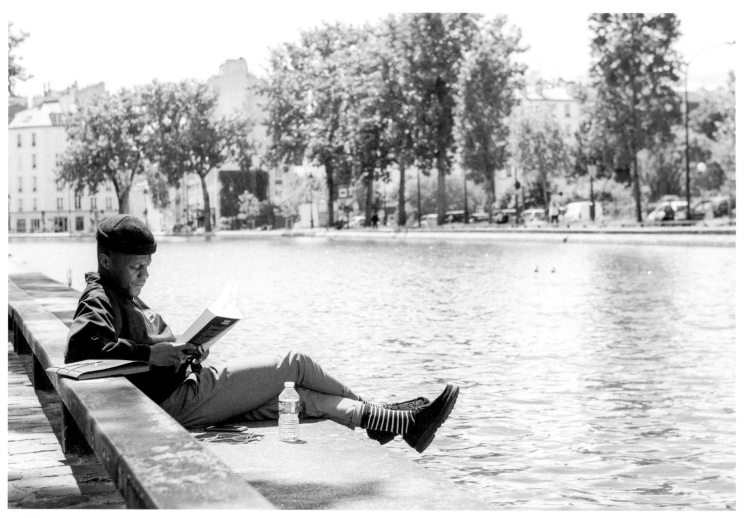

Wild canal swimming is illegal in Paris, but in 2017 the first designated swimming area opened in Canal de l'Ourcq, linked to the northern end of Canal St-Martin by way of the largest artificial lake in Paris, Bassin de la Villette. The floating pool structure can accommodate up to 300 swimmers at a time.

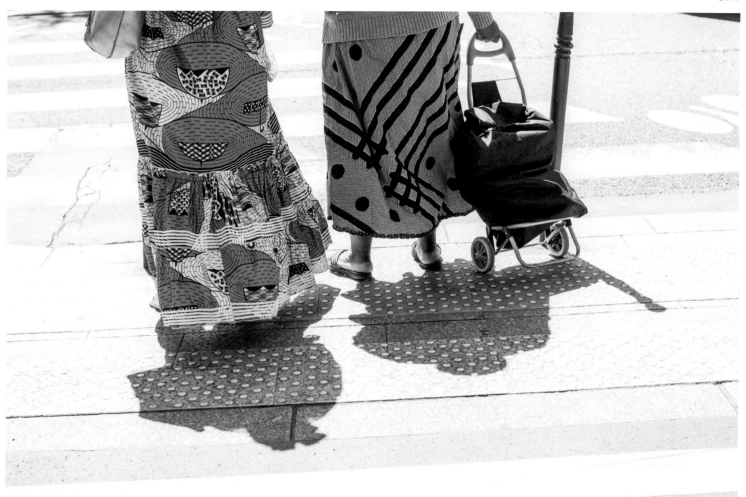

Tour multicultural Paris: shop for saris and curry spices in Little India around the partially covered Passage Brady in the 10e; sample Chinese noodles and Vietnamese pho bo in Chinatown in the 13e and Belleville; and enjoy Senegalese yassa while browsing colourful African fabrics in Goutte d'Or in the 18e.

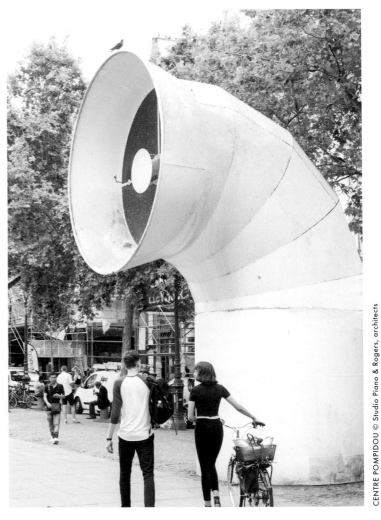

CENTRE POMPIDOU © Studio Piano & Rogers, architects

1600: For centuries France's leaders sought to immortalise themselves by erecting huge public buildings or *grands projets* in Paris. Enter the once-reviled, now much-loved Centre Georges Pompidou in the middle of the city, spearheaded by and named after the ex-French prime minister and unveiled in 1977.

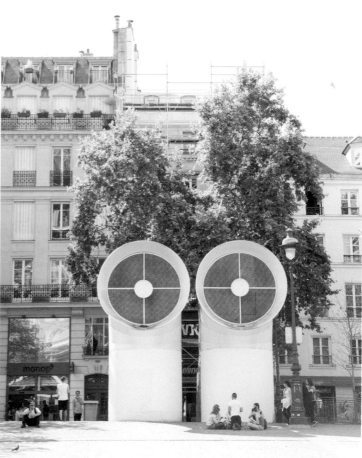

The arts centre houses Europe's largest collection of modern art and presents exhibitions, shows and debates. Its giant air vents loom large on Place Georges Pompidou. This fun-packed square and its nearby pedestrian streets attract plenty of musicians, jugglers, mime artists and other street entertainers on sunny days.

In Jardin des Plantes on the Left Bank reside a dodo, a sivatherium (a type of primitive giraffe), a horned turtle, a Barbary lion and other fanciful creatures who take children for a fantastical spin on a merry-go-round known as the Dodo Manège, which was dreamed up by a scientist from the nearby Natural History Museum.

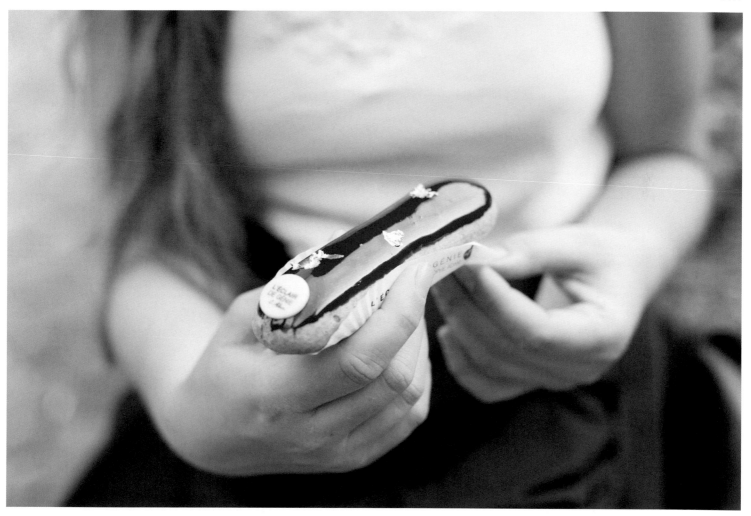

Forget bog-standard chocolate or vanilla, that icon of French patisserie, the éclair, is taken to new heights at Christophe Adam's Paris boutiques, L'Éclair de Génie. As with fashion, each season ushers in a new collection alongside rock'n'roll staples such as raspberry with white chocolate glazing.

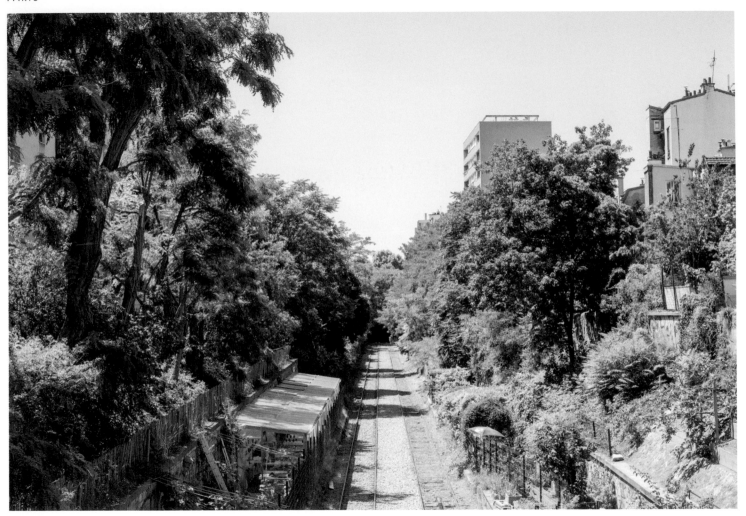

In the edgy neighbourhood of St-Ouen next to the world's largest fleamarket (Marché aux Puces de St-Ouen) lie abandoned train tracks that were once part of the Petite Ceinture ('little belt'). The line encircled central Paris for 30km (19 miles) from the late 19th century until 1934, when it closed to passenger trains.

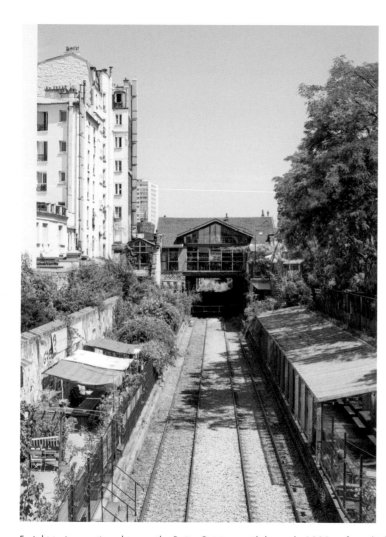

Freight trains continued to use the Petite Ceinture until the early 1990s, after which the tracks fell into disrepair until environmentalists turned their hands to upcycling the green space. Today, allotments and gardens cultivated by volunteers rub shoulders with pop-up cafes, antiques and bric-a-brac shops.

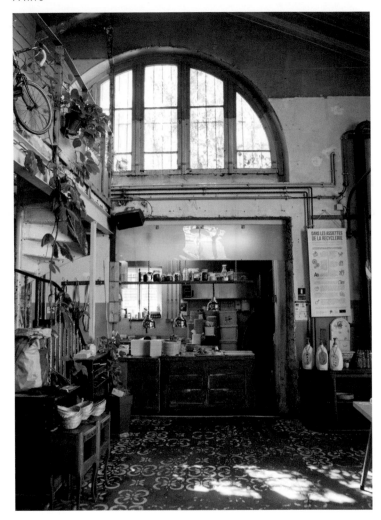

Seventeen of the original 29 stations on the line remain today. Gare Ornano, near Porte de Clignancourt, has found new life as an eco-conscious venture called La REcyclerie. The remodelled space embraces a repair and recycling workshop, garden, urban farm with chickens and ducks, collective veggie patch and beehives.

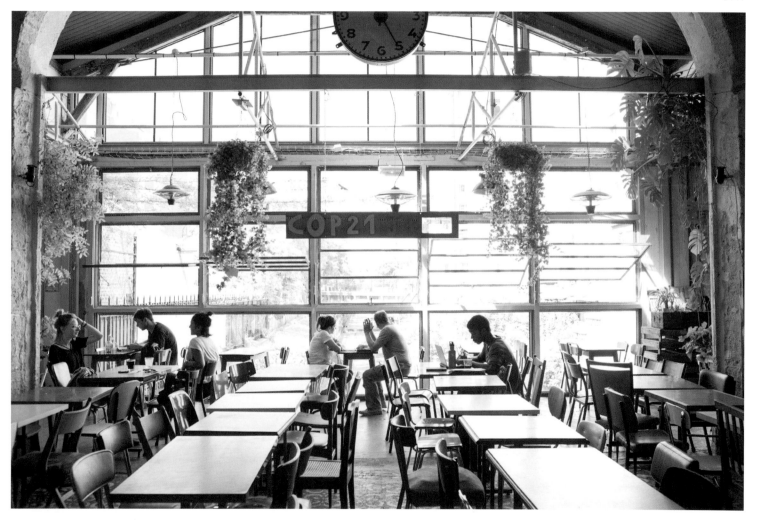

The pièce de résistance of La REcyclerie is its cavernous, light-filled cafe-canteen – a hot weekend date for Parisians after a shopping spree at the mind-boggling 2500 stalls of nearby Marché aux Puces de St-Ouen. Completely on-trend, the chef here cooks up a strict zero-kilometre, locavore cuisine.

Be it learning how to make your very own natural aloe vera-scented shower gel, dirtying your hands in the *potager* (veggie patch) garden, shopping for bric-a-brac, participating in a conversation, taking a workshop or relaxing with friends over brunch, La REcyclerie covers all bases.

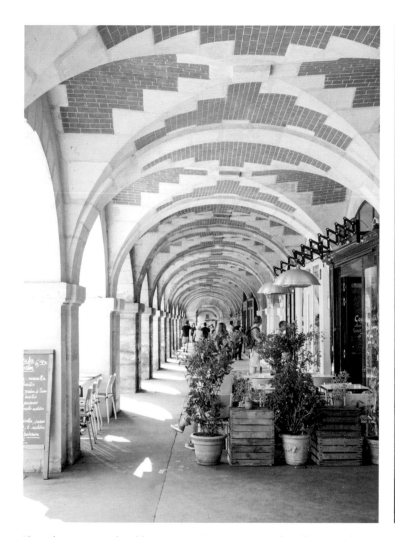

Place des Vosges is the oldest square in Paris, inaugurated as Place Royale in 1612. It was renamed in 1799 after the Vosges *département* (administration district), which was the first in France to pay its taxes. All 36 houses on the square are symmetrical, with red-brick arcades designed with meandering in mind.

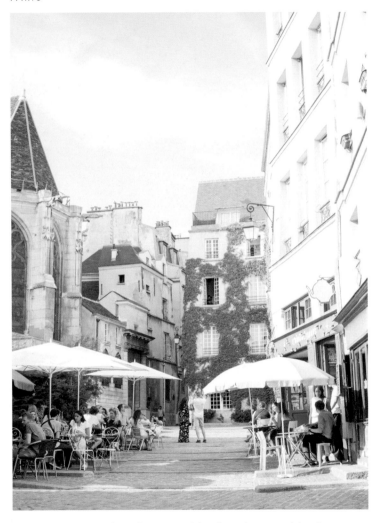

On quaint stone-paved Rue des Barres, L'Ebouillanté buzzes with locals sipping hibiscus-flower cordial and homemade *citronnade* (lemonade) with fresh ginger.

French boules and basketball, inline skating and outdoor table tennis: Parisians have always been big fans of *sport de plein air*.

The Marais (meaning 'marsh' or 'swamp') lived up to its name until the 13th century when the marsh was made into farmland producing vegetables for the city. It became a fashionable place to live in the early 17th century, and the area today, with its eco cafes and effortlessly stylish boutiques, remains achingly hip.

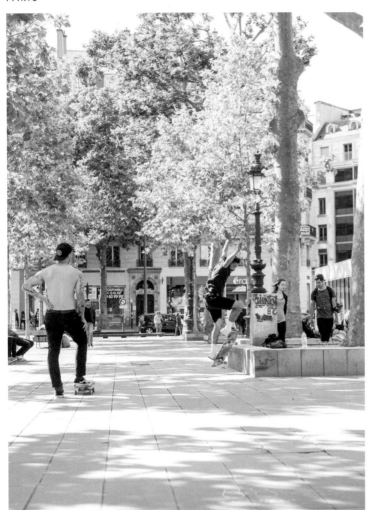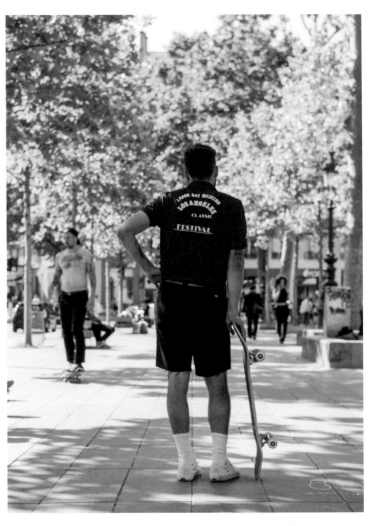

1700: There are manny pads, benches and ledges aplenty for frontsides, grinds and lip slides, making the vast smooth plaza of people-pulsating Place de la République a natural hub for the city's skateboarding scene.

In 2024, Paris will become the second city to host skateboarding – both street and park – as an Olympic event; the discipline will be introduced for the first time in Tokyo in 2020. Every September the French capital hosts the Paris Surf & Skateboard Film Festival, inspired by the city's dynamic skateboarding culture.

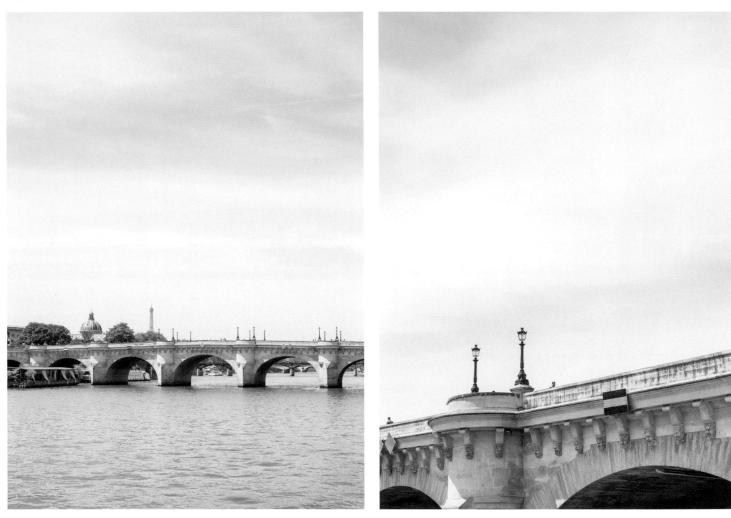

Pont Neuf – a design sensation in 1604 – is the oldest bridge in Paris. In the days when Parisians paid a boatman to row them from one side of the Seine to the other, a *pont neuf* (new bridge) was a momentous occasion. King Henry IV was the first to cross it, riding a white stallion no less.

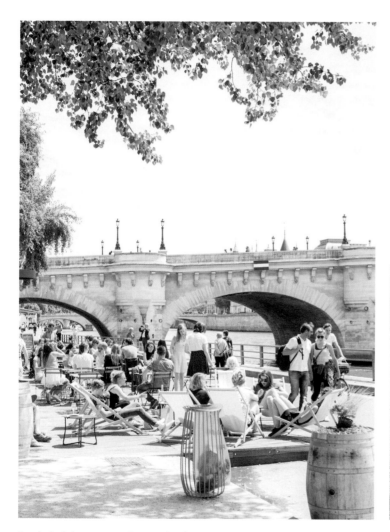

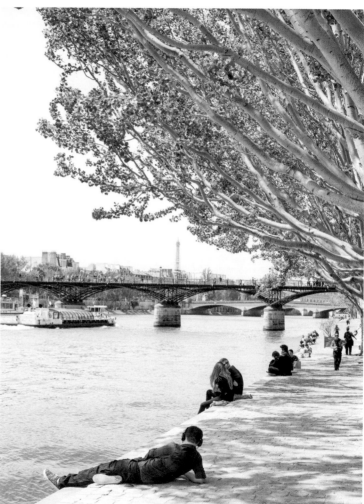

Sand, deckchairs, parasols, potted palm trees, water misters, ice-cream vendors, sandcastle competitions et al? It can only be Paris Plage along the Seine.

The picturesque Seine quays have been Unesco World Heritage-listed since 1991, and a giant backyard for apartment-dwelling Parisians for much longer.

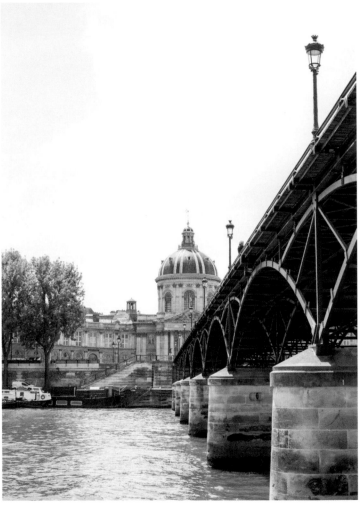

Thirty-seven bridges span the Seine. Two are train bridges and five are footbridges. Pedestrian Pont des Arts, in front of the Louvre, is known for the million love locks that used to weigh it down. Lovers inscribed their initials on a padlock, locked it to the bridge and tossed the key into the Seine to demonstrate their eternal love.

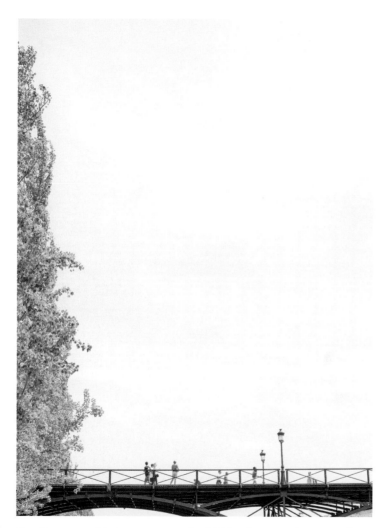

Sixty-five tonnes of locks were removed in 2015 and auctioned two years later. The money raised was donated to charities working with refugees.

White, the dynastic colour of the House of Bourbon, was mixed with the city's traditional red and blue to create the French flag after the French Revolution.

From Monday to Friday the cobbled alleys walked by artisans, antique dealers and gallerists are wonderfully tranquil, but come the weekend (and during the monthly flea market) Parisian fashionistas mingle in Village St-Paul, a designer set of five vintage courtyards in the trendy Marais district.

116

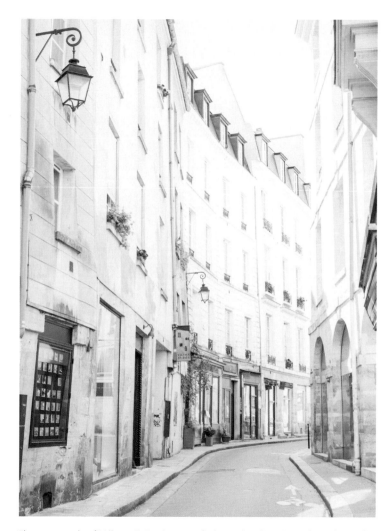

The courtyards of Village St-Paul were refashioned in the 1970s from the 14th-century walled gardens built by King Charles V. Nowadays, bijou artisan boutiques, galleries and antique shops fill the labyrinth – find them via entrances on the Rue Saint-Paul, Rue Ave Maria, and the St-Paul and Charlemagne gardens.

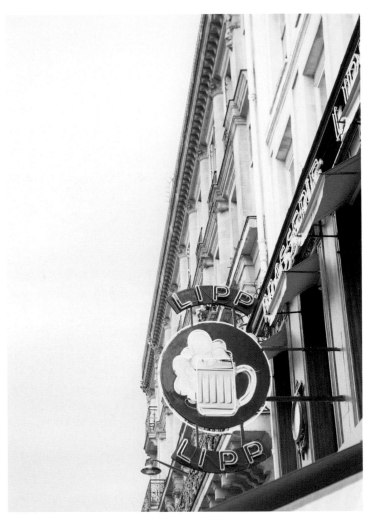

Fashionista Paris comes to life on Boulevard St-Germain, the hub of St-Germain des Prés, the city's most cinematic *quartier* on the Left Bank.

In the early 20th century, Ernest Hemingway and the city's literati hung out at Brasserie Lipp, a bar-restaurant on Boulevard Saint-Germain since 1880.

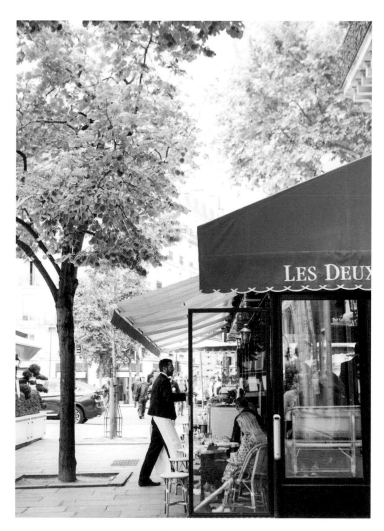

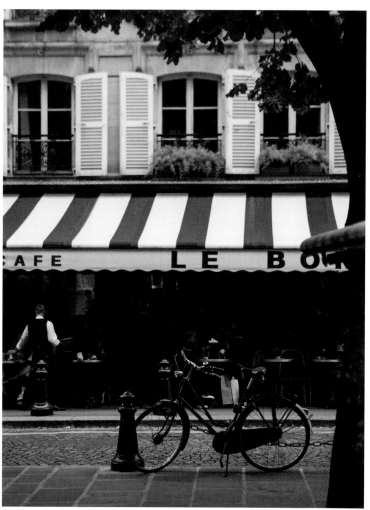

Nowhere evokes St-Germain's 20th-century literary scene like Les Deux Magots, where Simone de Beauvoir and Jean-Paul Sartre famously sat, thought and wrote.

Grab a pew outside legendary Le Bonaparte for views of one of Paris' oldest churches, the 6th-century Église St-Germain-des-Prés. Descartes is buried inside.

119

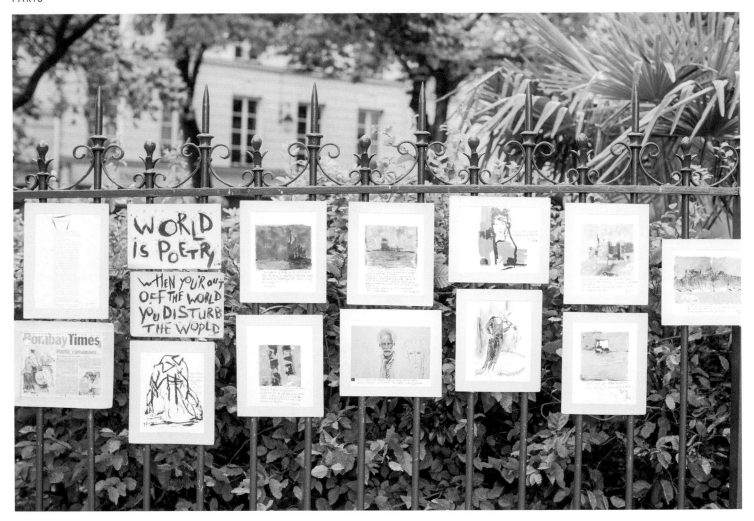

Outside the church, street railings double as an art space for the paintings and drawings of Delhi-born street artist Yaseen Khan. Khan's eye-catching work mixes short lines of heartfelt poetry – some original, some borrowed, all highly pertinent – with paintings of people with triangular heads, in watercolours and ink.

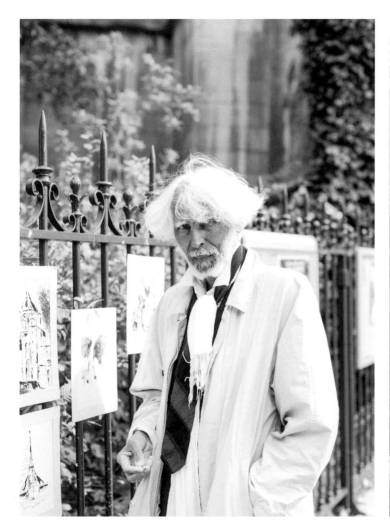

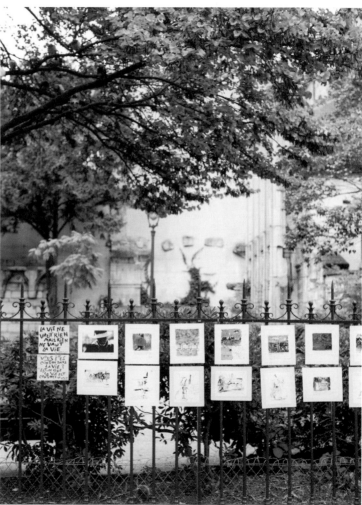

Now in his seventies, Yaseen Khan has spent more than half his life in Paris and is part of local life in St-Germain. An air of mystery and all the traits of a debonair gentleman aside, he is easy to spot with his signature white suit and shirt, complemented by white coat in winter, straw hat in summer and always a necktie.

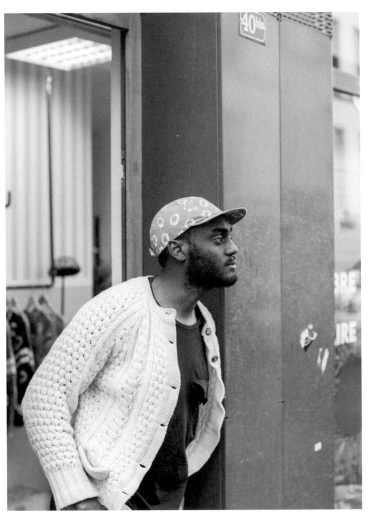

In the 18e in northern Paris, multicultural Château Rouge is enjoying a whole new image thanks to the overnight success of urban fashion label Maison Château Rouge. It was launched in 2015 by Youssouf Fofana and his brother, Mamadou, and is a vibrant celebration of grass-roots Afro-Parisian culture.

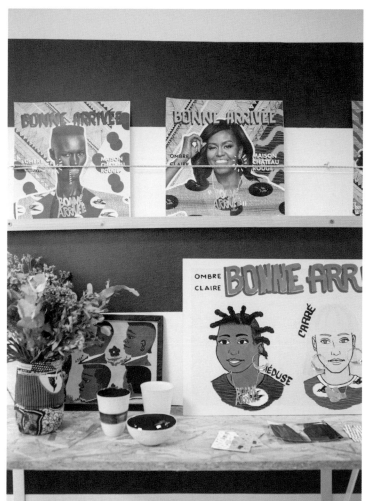

Minimalist, gregarious, kitsch and hipster 'afropolitaine' in equal measure, Maison Château Rouge is one of the city's stunning, new-generation 'Made in Paris' labels. Its concept store at 40 rue Myrha, 18e, also sells Senegalese music, Bana-Bana bissap juice, African crafts et al.

Named after a 17th-century red-brick mansion demolished in 1875, Château Rouge is one of Paris' most multicultural 'hoods, often nicknamed 'Little Africa' for its sizeable African community. Its streets, lined with Afro hair-dressing salons and grocery stores, buzz with a frenetic energy not found anywhere else in the capital.

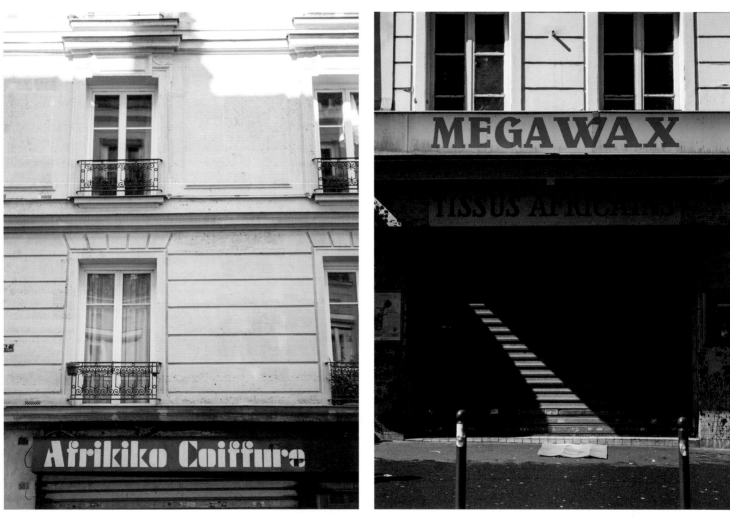

As well as being home to many African businesses, Château Rouge is the name of a spicy red beer made by local craft brewery Brasserie de La Goutte d'Or, a hop (ahem) and a skip from Château Rouge metro station and a perfect reflection of the gutsy, multi-ethnic *quartier* in which it was born and thrives.

125

The city's largest urban cultural park, Parc de la Villette, sprawls at the intersection of two canals, the Ourcq and the St-Denis, in northern Paris. It was designed by French-Swiss architect Bernard Tschumi and encompasses concert halls, playgrounds and themed gardens recreating dragons, sand dunes and a mirror maze.

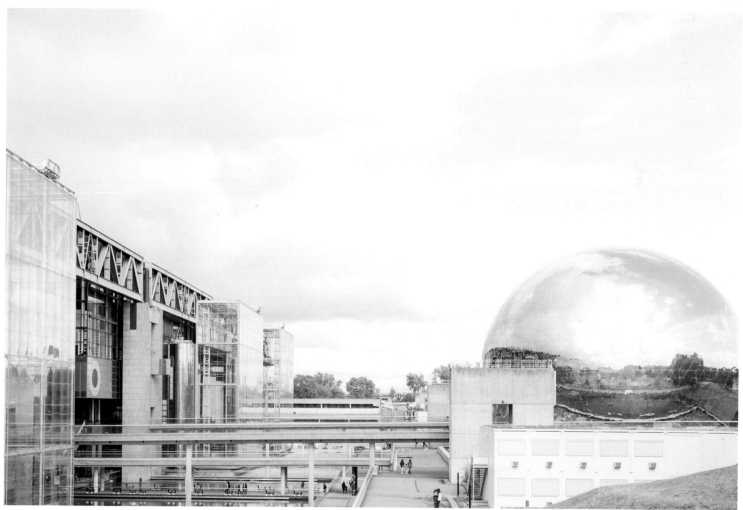

The colossal mirror-like sphere of the special-effect cinema La Géode, known for its 3D movie screenings, is one of the park's most dazzling features. It sits next-door to the Cité des Sciences et de l'Industrie, Paris' top museum for kids, with three floors of hands-on science and technology exhibits.

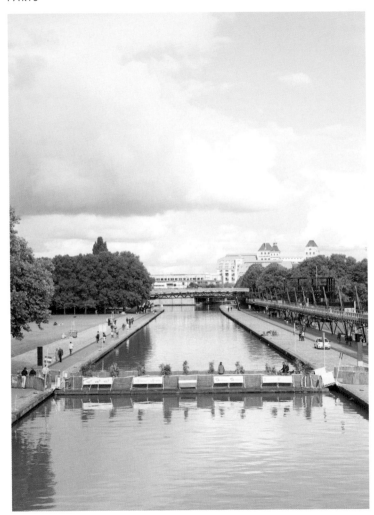

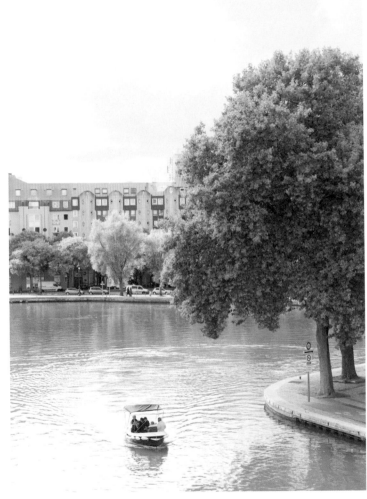

The park's red cubical *folies* reference 18th-century architectural follies and have playful names like Folie du Bout du Monde (Folly from the End of the World).

The 19th-century Canal de l'Ourq was built to supply the city with water. Its first 20km are free of locks and can be sailed in a little electric tourist boat.

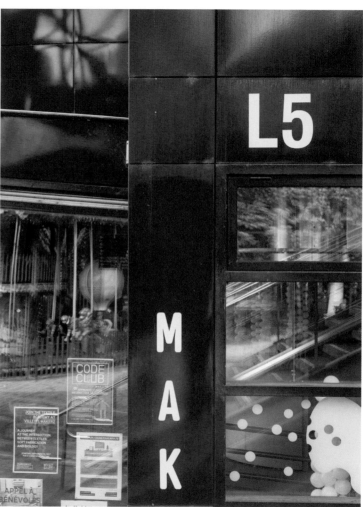

Pedestrian-friendly quays line the 108km Canal de l'Ourq. From the Bassin de la Villette, watch the 1885 Pont de Crimée open to allow boats though.

The largest of Parc de la Villette's folies is L5, or Folie des Merveilles. Its three floors are home to a collaborative digital design-lab called Villette Makerz.

129

Brunch, tea or a post-work apéritif: Le Jardin de la Petite Halle is a one-shop social stop. It's across from cultural centre La Petite Halle in Parc de la Villette.

Of the three halls that existed when Villette was a livestock market, La Grande Halle is the only one remaining. It's a protected historic monument today.

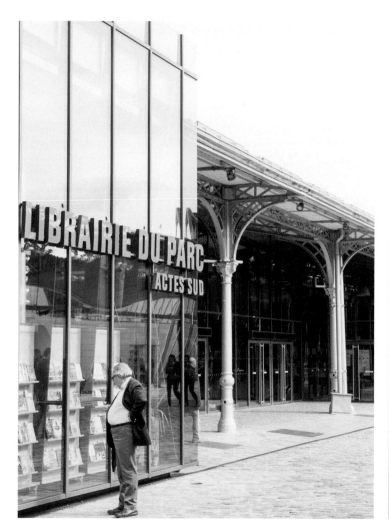

Browsing the shelves of the Librairie du Parc-Actes Sud, inside La Grande Halle, it's hard to believe that 5000 oxen and 23,000 sheep were slaughtered daily at the abattoir sited here in the early 20th century. Unsurprisingly, the bookshop houses a huge collection of titles covering La Villette and its canals.

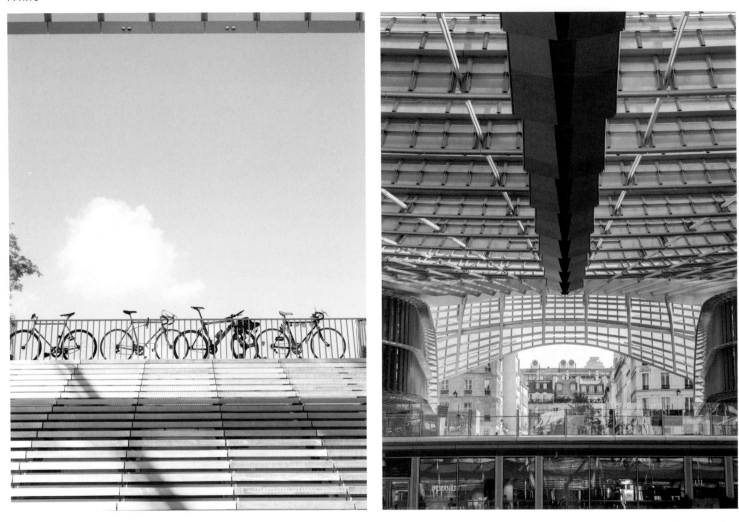

La Grande Halle looms large at Parc de la Villette's southern entrance. The square in front, Fontaine aux Lions, was once lined with drinking troughs for livestock. The abattoirs closed for good in 1974, making way for the striking and futuristic work of urban architecture that Parc de la Villette is today.

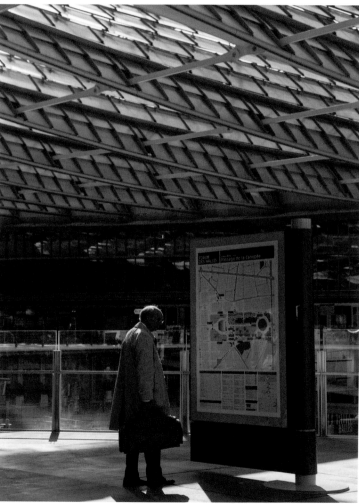

In the 1st arrondissement, behind the city's original marketplace Les Halles, rise the Gothic spires of the Église St-Eustache. The glossy Forum des Halles shopping mall marks the spot where Louis VI created wholesale *halles* (markets) in 1137 for the merchants who converged on the city to sell their wares.

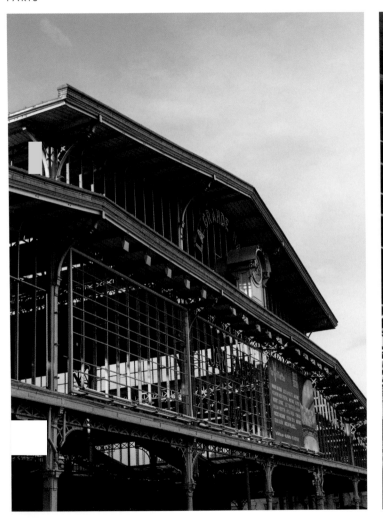

1800: As the day ends, La Grande Halle shifts gears: galleries, an auditorium and a cinema are just some of the cultural venues on offer in the 19th-century iron-and-glass edifice – big enough to serve cocktails to 10,000 people. And at Parc de la Villette, classical music lovers head into the more modern La Cité de la Musique.

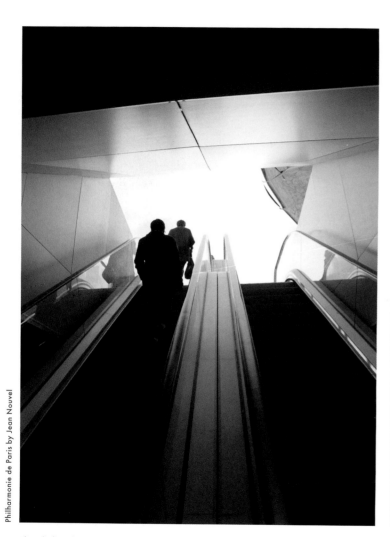

Philharmonie de Paris by Jean Nouvel

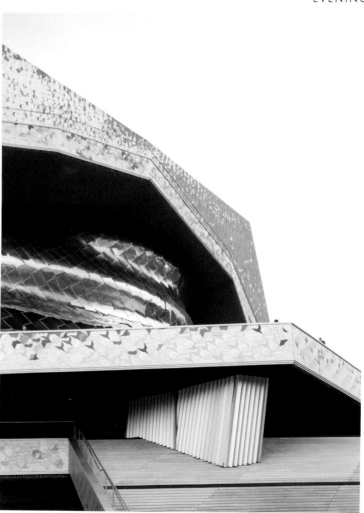

The slinky silver contours of next-door neighbour, Jean Nouvel's dazzling Philharmonie de Paris, were unveiled in 2015. The concert hall is part of the La Cité de la Musique group of buildings in Parc de la Villete in the 19th arrondissement. Panoramic views of the entire park from its rooftop are second to none.

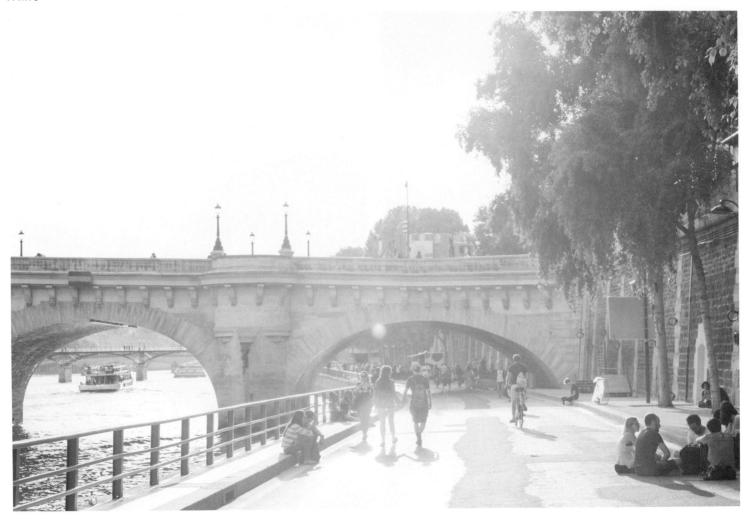

Boasting 12 handsome stone arches and the Île de la Cité in the middle of it, Pont Neuf is a bridge to admire from all angles. Strolling beneath it reveals the faces of 381 stone *mascarons*, mythical creatures decorating both sides of the bridge. Designed to scare off evil spirits, each wears a different expression.

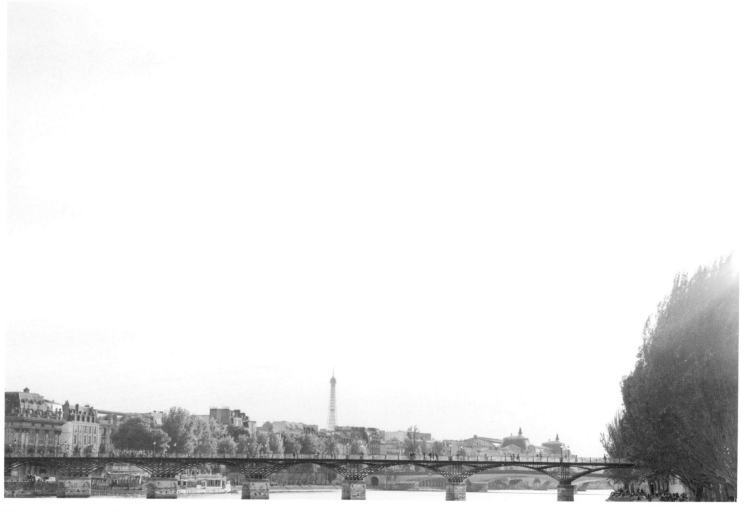

The Seine is the lifeline of Paris, looping through the heart of the city and bordering 10 of its 20 arrondissements. Parisians are staunchly loyal to their side of the river: the southern Rive Gauche (Left Bank) was traditionally bohemian, the northern Rive Droite (Right Bank), traditionally aristocratic.

 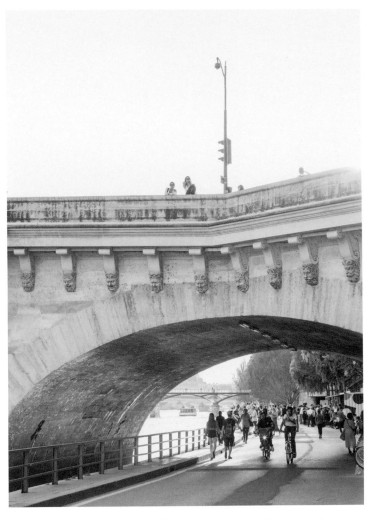

The renaissance of the Seine riverbanks has been a new-millennium joy for Parisians who enjoy pedestrian-friendly walkways and cycling paths on riverside embankments where cars once sped. This Berges de Seine playground embraces the strips from Pont d'Alma to Pont Royal, and from Pont Neuf to Pont de Sully.

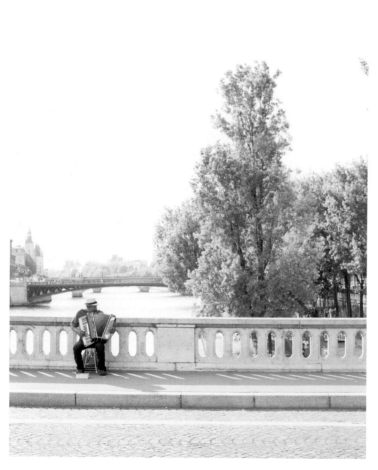

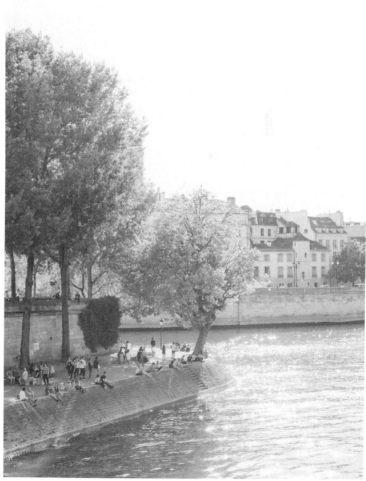

Pont au Change, the bridge in Victor Hugo's classic *Les Misérables*, is a popular spot with crowds who are entertained by street musicians and other artists.

The tip of tear-drop-shaped Île de la Cité is impossibly romantic come late afternoon, when people gather to watch the sun set over the Seine.

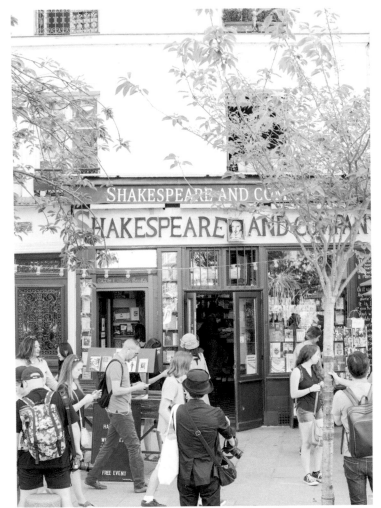

Paris' most magical bookshop, Shakespeare and Company, has been the city's home for new and second-hand books in English since 1951. The original shop (at 12 rue l'Odéon, 6e, closed by the Nazis in 1941) was run by Sylvia Beach and was an illustrious meeting point for Hemingway's 'Lost Generation'.

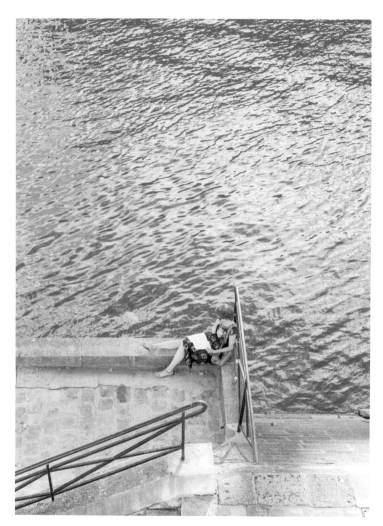

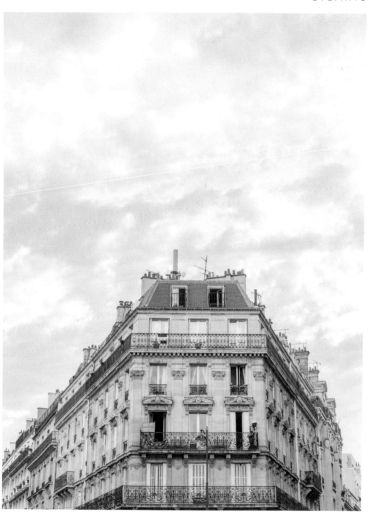

The high embankments and graceful buildings ensnaring the hypnotic Seine were only engineered in the 19th century. Until then, barges transporting wheat, wine and other goods to the city docked at the water's edge and unloaded on muddy, unpaved riverbanks bordered by half-timbered, squat and dark houses.

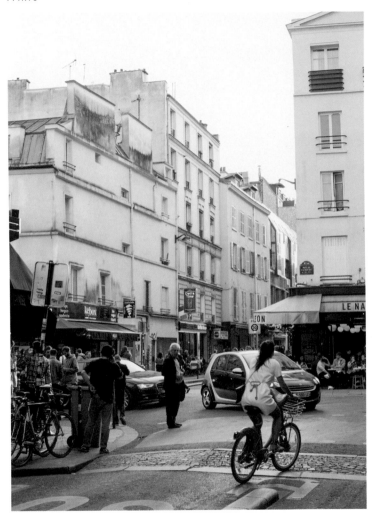

1900: *La vie de quartier* (neighbourhood life) remains alive and well in Château d'Eau, a cosmopolitan pocket of Paris immediately west of République in the 10e. Since the 1990s it has been known for its African hair salons and wig shops, tucked between more traditional épiceries, tabacs and cafes.

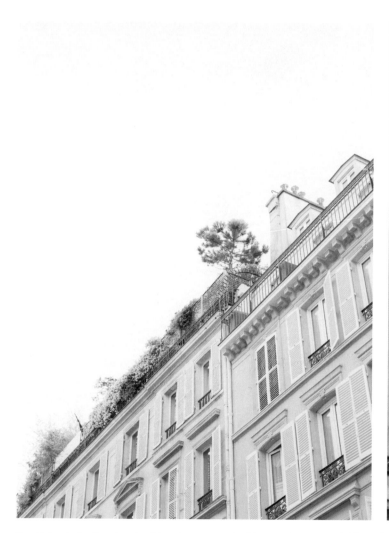

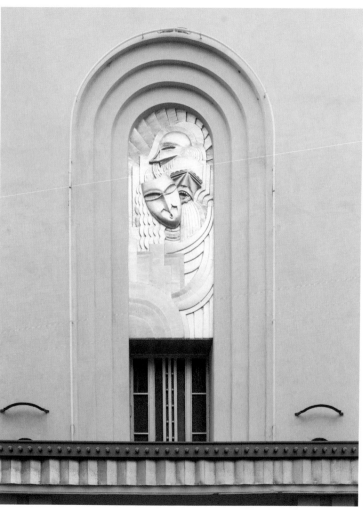

Rue Richer in the 9e mixes traditional apartment buildings with saucy nightlife. Cabaret Folies Bergère (1869) at No 32 found fame as the spot where African-American dancer Josephine Baker appeared wearing a skirt of bananas and little else in 1926. Its dazzling Art Deco façade was completed the same year.

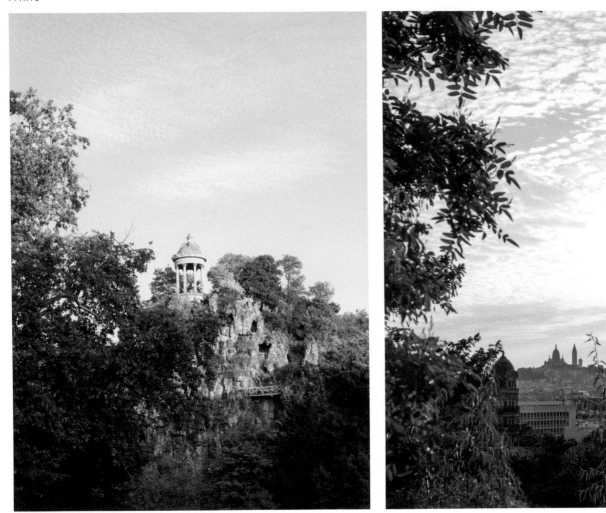

Parc des Buttes-Chaumont, created in 1867 on the city's northeastern fringe, is Paris' sunset-romantic park. The crowning glory of its eclectic landscaping is the Temple de la Sibylle, an architectural folly inspired by an ancient Roman temple in Italy. Find it perched atop a rocky cliff in the middle of an artificial lake.

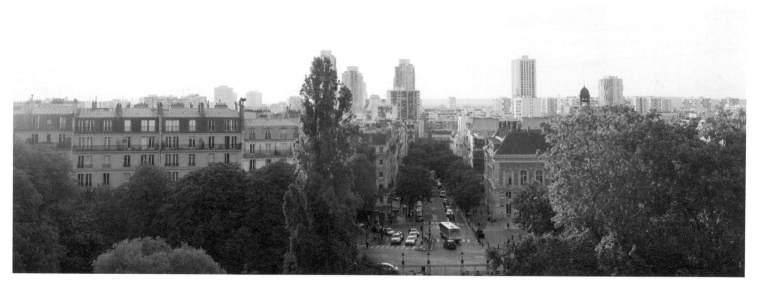

The Buttes-Chaumont neighbourhood only became part of Paris in 1860. Until then, it fell outside the city walls and was known for its grim gypsum quarries and grisly gallows where, from the 13th century until 1760, traitors were hanged and displayed after their executions at the Gibbet of Montfaucon.

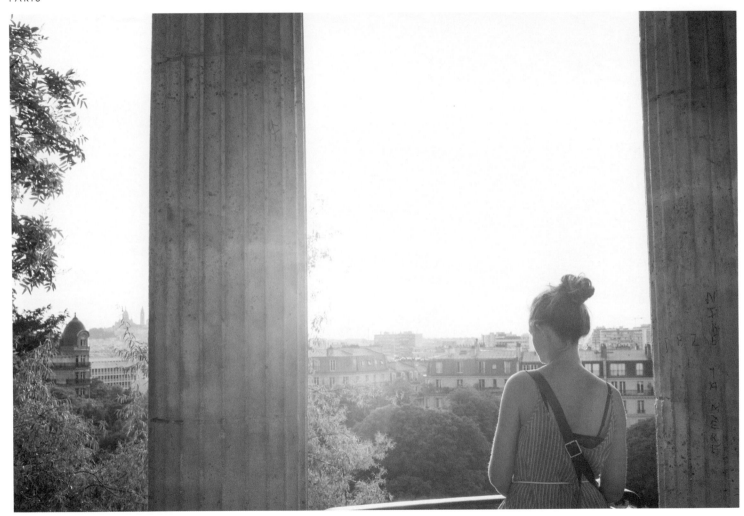

City views from the hilly Parc des Buttes-Chaumont are naturally stupendous. Waterfalls, vintage grottoes, mountains of flora and fauna, and a gorgeous 63m-long iron suspension bridge designed by Gustave Eiffel himself add to the charm.

'In summer, Parc des Buttes-Chaumont is the ultimate place to end a day in the city. Its steep hills are one of the last spots the golden sun hits before it sets. Along with my heavy photography kit, I was hauling a bag packed full of fresh bread, charcuterie and cold beers up and down the steep hills, safe in the knowledge that at some point my job would be done and I could join the peaceful people speckled on the urban hills, watching Paris change from evening to night.'

- *River Thompson*

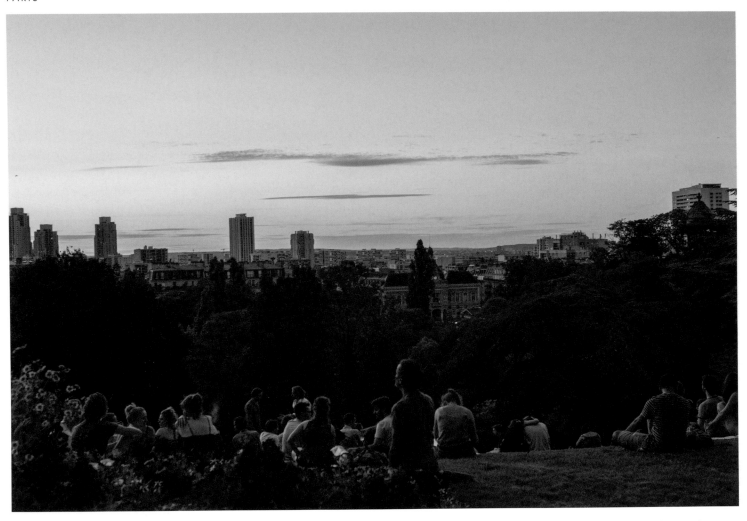

2000: Play the nocturnal Parisian picnicker: grab a picnic blanket, baguette, gooey round of Camembert, bottle of red or Champagne, and join the crowds watching the sun turn the Parisian sky every shade of pink, orange and red from the grassy hillside in Parc des Buttes-Chaumont.

Parc des Buttes-Chaumont proffers one of the finest unobstructed views of the Paris skyline *sans* the tourist hordes. Should there be no space for your picnic rug, head to nearby Butte Bergeyre, an even more secret butte (hill) sporting equally dramatic skyline views.

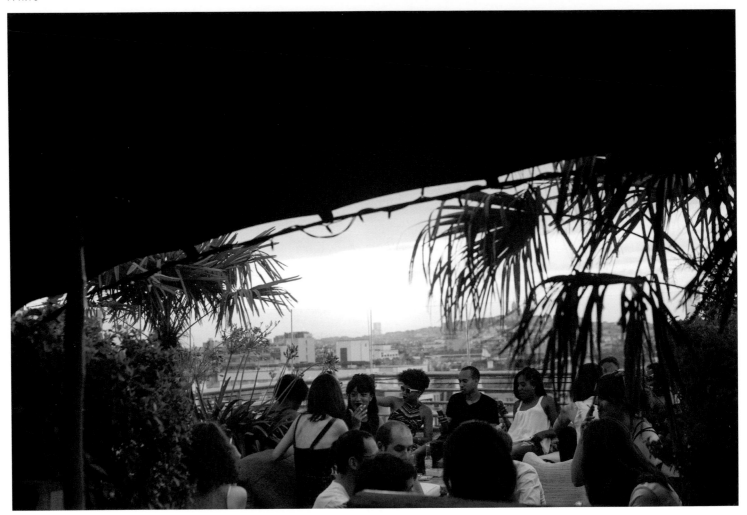

2100: Hipsters in the know – there is no sign at street level – toast the start of the weekend with cocktails at Le Perchoir, an achingly cool rooftop bar and 6th-floor loft restaurant inside an industrial building in grungy Ménilmontant. The mood is bohemian chic; the 360-degree view unrivalled of Paris by night.

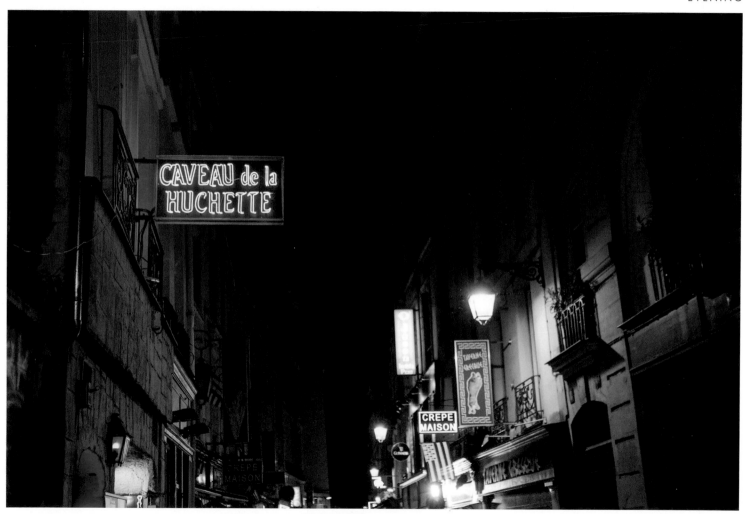

There is no more legendary temple of swing than Caveau de la Huchette, hidden in a labyrinthine 16th-century cellar that was used as a courtroom and torture chamber during the French Revolution. Its more enjoyable pastimes began in 1949 when the music venue and club opened its doors to a jazz-hungry Paris.

'Le Caveau de la Huchette is a legendary jazz club tucked down a cobbled street, hosting live music every day of the week. After meeting the band who were performing that night, I knew they would photograph well. I just had to figure out how precisely I would capture them, while avoiding the spins and lifts of the busy dance floor. It quickly became apparent that a handful of older men and women were hardcore regulars who would be dancing well into the early hours. One grabbed my hand as I scurried across the dance floor for some last portraits – luckily I had the camera to blame!'

- *River Thompson*

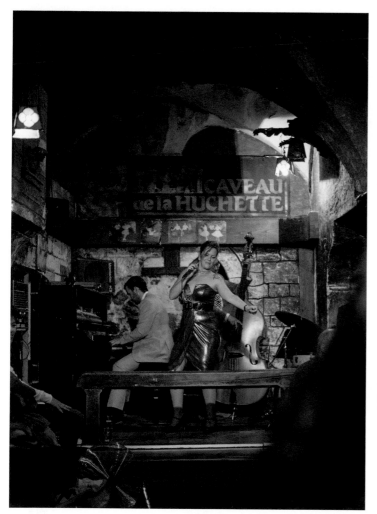
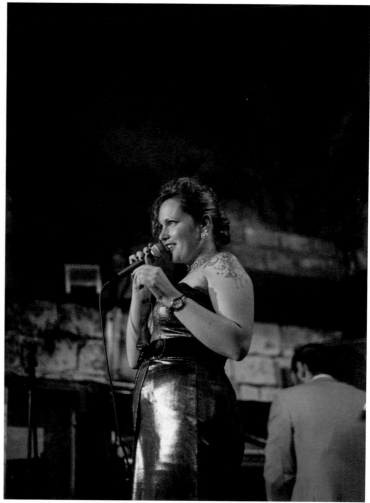

2200: French quartet Marie-Laure Célisse & the Frenchy's rock the stage with their swing adaptations of classic French songs at Caveau de la Huchette in the Latin Quarter. The elegance, glamour and seductive vibe of 1950s Paris is electric.

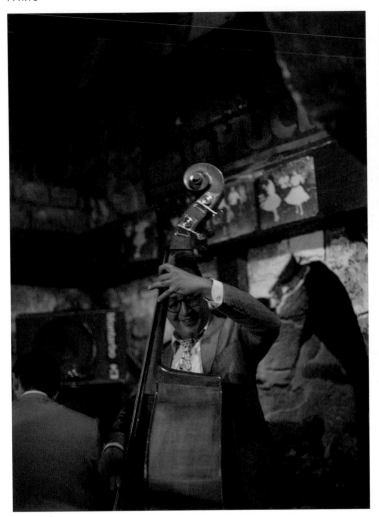
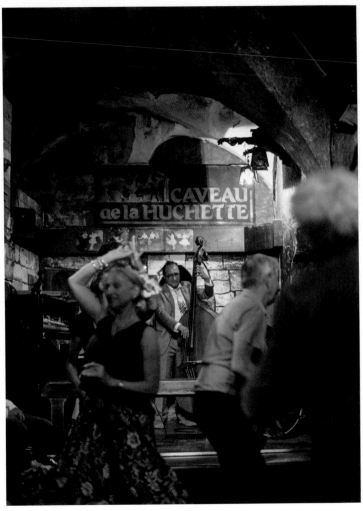

Many of jazz's greats – Art Blakey, Count Basie, Scott Hamilton, Georges Brassens, Ronald Baker et al – have performed here. With Brahim Haiouani on double bass, César Pastre on piano and Germain Cornet on the drums, it's impossible not to bop. Talented vocalist Marie-Laure turned to jazz singing after studying flute.

For rockier sounds, Le Trabendo, at home in one of Parc de la Villette's red pavilions, has been one of the city's hottest live-music venues since the 1990s. Gigs and DJ-driven club nights set the place pulsating seven nights a week – Ben Harper, Metallica, Manu Chao and Green Day performed here early in their careers.

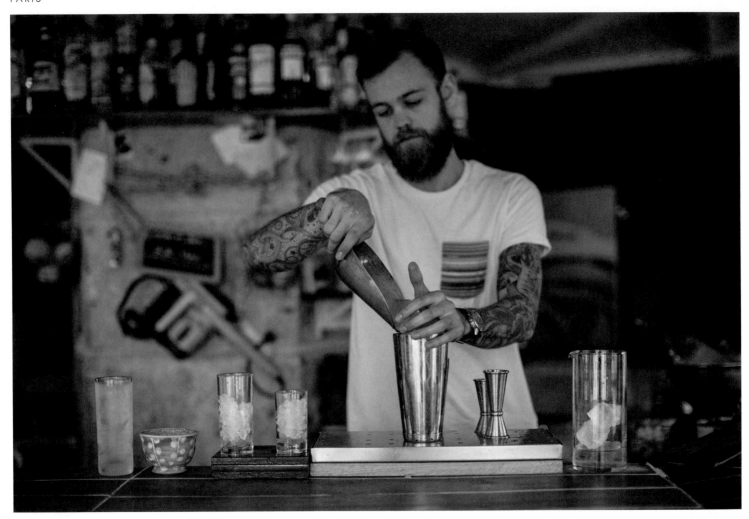

2300: In the fashionable Marais, head barman and manager Simon Wittrup whips up a carefully crafted cocktail at Le Mary Celeste. Brought to the city by the team behind Candelaria and Glass, the uber-popular brick-and-timber-floored venue was among the city's first new-generation cocktail bars to open.

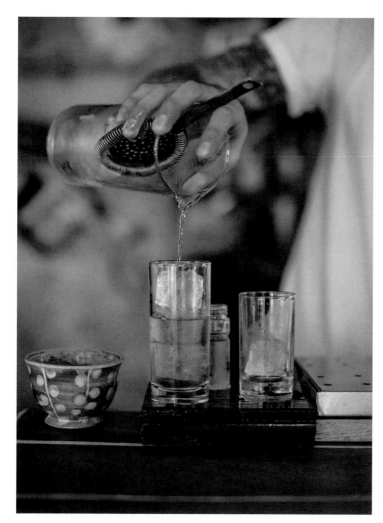

Le Mary Celeste pairs well-mixed cocktails with oysters (from September to April) and delectable gourmet tapas dishes to share. Cuisine is fusion, syrups are strictly *fait maison*, cocktails brilliantly creative.

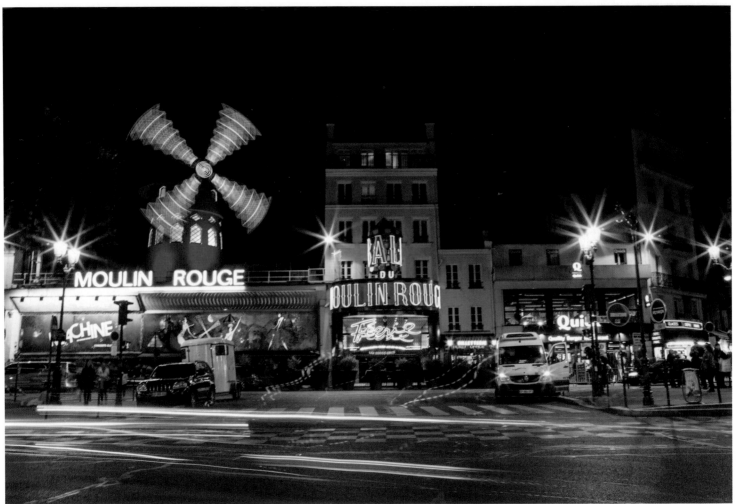

Immortalised in Toulouse-Lautrec's posters and later in Baz Luhrmann's eponymous film, Paris' legendary Moulin Rouge cabaret twinkles beneath a 1925 replica of its original red windmill. The original, which burned down in 1915, began life in 1889 and was a vibrant part of fin de siècle Montmartre.

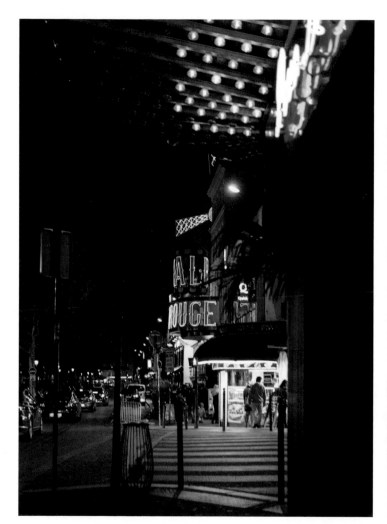

Yes, the Moulin Rouge gets packed with bus-tour crowds. But from the opening bars of music to the last high cancan-girl kick, the city's best-known cabaret is a magical whirl of fantastical costumes, sets, choreography and Champagne. Dress smartly (no sneakers).

Published in May 2018 by Lonely Planet Global Limited
CRN 554153
www.lonelyplanet.com
ISBN 978 1 7870 1345 2
ISBN (US) 978 1 7870 1847 1
© Lonely Planet 2017
Printed in China
10 9 8 7 6 5 4 3 2 1

Publishing Director Piers Pickard
Associate Publisher & Commissioning Editor Robin Barton
Art Director Daniel Di Paolo
Photographer River Thompson
Writer Nicola Williams
Editors Yolanda Zappaterra, Nick Mee
Print Production Larissa Frost, Nigel Longuet
Thanks to Flora Macqueen

STAY IN TOUCH lonelyplanet.com/contact

AUSTRALIA The Malt Store, Level 3, 551 Swanston St, Carlton, Victoria 3053 T: 03 8379 8000

IRELAND Digital Depot, Roe Lane (off Thomas St), Digital Hub, Dublin 8, D08 TCV4

USA 124 Linden St, Oakland, CA 94607 T: 510 250 6400

UNITED KINGDOM 240 Blackfriars Rd, London SE1 8NW T: 020 3771 5100

Paper in this book is certified against the Forest Stewardship Council™ standards. FSC™ promotes environmentally responsible, socially beneficial and economically viable management of the world's forests.